IMAGES
of America

LANCASTER
REVISITED

76/400

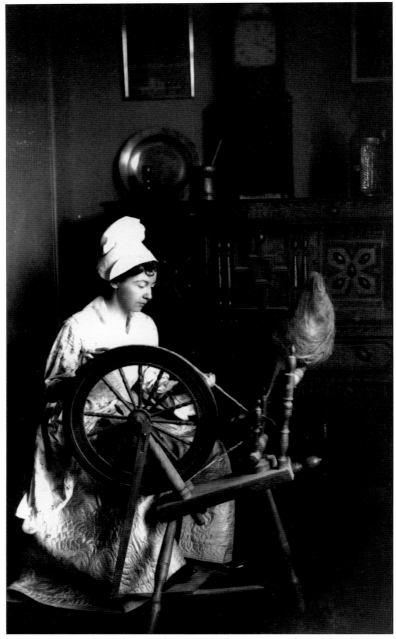

ROWLANDSON LOCKER. When the Rowlandson locker was purchased by the Lancaster Town Library in 1876 with money bequeathed by native Mary Whitney, it no doubt awakened an interest in the early history and daily lives of settlers. An unidentified woman, dressed in period garb, works an ancient spinning wheel in the foreground of this late-19th-century photograph.

On the cover: Four unidentified men relax in back of the A. L. Safford store in Lancaster Center in the early 1900s. The photograph was taken by James A. MacDonald.

IMAGES
of America

LANCASTER
REVISITED

Heather Maurer Lennon

ARCADIA

*Dedicated to my sister Kris, whose inspiration
and encouragement launched this entire project.*

LANCASTER HISTORICAL SOCIETY
AND COMMISSION. Founded in 1989,
the Lancaster Historical Society
(LHS) is a nonprofit organization
open to all. The Lancaster Historical
Commission (LHC) was established in
1963 by approval at the town meeting.
Members are appointed by the town's
selectmen. Michael Sczerzen is president
of the LHS and chairman of the LHC. Joan
Richards is the secretary of the LHS and office
coordinator for the LHC.

CONTENTS

ACKNOWLEDGMENTS

Most of the images shown and much of the information provided in this book come from the archives of the Lancaster Historical Commission. Many of the photographs are the work of Lancaster photographers James MacDonald and Alice Greene Chandler. Once again, a very special thank-you goes to Michael Sczerzen for his support throughout the project and his help with selecting and arranging images. Special thanks also go to Joan Richards, who has been extremely helpful in locating key information and images in the archives, and to Phyllis Farnsworth for her fine review. I am grateful to Roy Christoph for his valuable assistance in getting key photographs needed for the project and to Beryl Christoph for providing leads in my search for little-known tidbits of town history.

I would like to credit the Lancaster Historical Society as a whole for its support and also the following individuals and institutions for their input in the form of images and information: Atlantic Union College (AUC), Rona Balco (Balco), Roy and Kristen Christoph (Christoph), Culley's Skimobile Ranch and family (Culley), Phyllis Farnsworth (Farnsworth), Dr. Geraldine Grout (Grout), Roger Hart (Hart), Historic New England (SPNEA), Clinton Daily Item (Item), Chris Jacobs (Jacobs), William A. Kilbourn (Kilbourn), Gail Mason Laurence (Laurence), Gloria Willruth Maurer (Maurer), Frank MacGrory (MacGrory), Joyce Millet (Millet), Frank and Joan Mitchell (Mitchell), Nashoba Regional High School (NRHS), Mary Dyment Paquette (Paquette), O. W. Holmes Library at Phillips Academy (Phillips), Frank and Lois Ponte (Ponte), John Charles Schumacher-Hardy (Schumacher-Hardy), Michael Sczerzen (Sczerzen), Thayer Memorial Library (TML), Thayer Symphony Orchestra (TSO), and Jean Watson (Watson).

INTRODUCTION

In the 19th century, the United States was an expanding nation, having grown from a narrow fringe of eastern states to a continent-wide nation of 76 million. As part of this trend, rural New England lost much of its population to the cities and to the west.

In the decades after Clinton, her last "daughter town," broke away in 1850, Lancaster, Massachusetts, grew slowly. In 1900, the town was typical of rural America, where 60 percent of the population lived in communities of less than 2,500 or on farms. It was a peaceful place, somewhat an island of stability against the faster pace of modern times.

The neat cottages and quaint farmhouses, coupled with the stately elms, rolling hills, and broad fields, made Lancaster a tourist destination in a time when "the trees alone" were thought to be worth a trip. The Lancaster House drew guests each summer, and rooms in local farmhouses were rented by summer boarders. Views from this golden age of postcards reflect the quiet beauty of the surroundings in Lancaster during this time.

In the 20th century, however, the appearance of the town began to change. Lancaster was becoming more exclusively residential. The wealthy Thayer family, acquiring land along Main Street, George Hill, and the Back Road for their many estates influenced this. The earlier industries of the 19th century—hat, boot, and shoemaking and printing—then migrated to nearby Clinton or disappeared entirely.

Beginning in the 1920s, the federal government stepped in and altered the town as well. During World War I, it had leased 800 acres of land in Lancaster. In 1923, the land was purchased. Again, from 1932 to 1942, more land was acquired, bringing the total to over 4,000 acres. The latter purchase involved some 200 pieces of property, forcing residents on some of the choicest acreage in the township to move. Old homes in the Ponakin area disappeared, some of them demolished during target practice.

In the mid-20th century, Lancaster's largest village, South Lancaster, also changed as the result of a program to develop the campus of Atlantic Union College. In 1938, officials decided that if the college were to truly fulfill its mission, it would need to acquire land, provide suitable buildings, and increase the faculty. Funds were voted to start an expansion movement. Much of this took place from 1936 to 1948 under college president G. Eric Jones.

As Lancaster is situated near the converging branches of the Nashua River, water has always been a significant part of the town. This became very apparent when a hard winter, an early thaw, and torrential rain produced the flood of 1936 and left its mark. The Nashua River

flooded, destroying all bridges and isolating Lancaster Center for many days. This was soon followed by another significant weather event.

On September 21, 1938, a ferocious category-three hurricane, sprinting up the Atlantic coast at a mile a minute, caught the Northeast by surprise, leaving a trail of death and destruction. In Lancaster, many lofty elms were lost. The pride of the town since Colonial times, these majestic trees came crashing down across streets and onto rooftops. The Nashua again swelled and overflowed its banks, washing out bridges and leaving many stranded and unable to return home—some for days. Property damage was widespread, and the town was left without lights and telephones for many weeks.

A few years later, these natural disasters were followed by the human disaster of World War II. From 1941 to 1945, no fewer than 279 men and 13 women from Lancaster were inducted into the armed services. Five servicemen from Lancaster were lost, including young Hugh "Buddy" Connor, who was killed in a battle in the Pacific theater.

In the 18th and 19th centuries, small one-room schoolhouses had been located in districts all over Lancaster. As transportation became better, centralized schooling began. In the early 20th century, the Ballard Hill, Center, and Narrow Lane Schools were used in the North, Center, and South Villages. Though each had more than one classroom, grades were still combined. Midcentury, the Ballard Hill and Narrow Lane Schools were closed and students were sent to Lancaster Center, where the new Tercentenary Building (1953) and Memorial School (1956) were put to use. In 1974, the Lancaster Middle School opened and, in 2002, was renovated and renamed the Luther Burbank Middle School. The adjacent Mary Rowlandson Elementary School also opened in 2002. Schooling for students from kindergarten through eighth grade is now completely centralized.

Lancaster High School, in its new building (constructed 1903–1904) on the town green, served the needs of students from grades 9 through 12 until Nashoba Regional High School opened in 1961, serving Lancaster, Bolton, and Stow. When it opened, the school plant and equipment were valued at about $1,700,000. With 45 staff members, including 28 teachers, the payroll was close to $220,000, making it a very large economic factor in the area at the time.

As the 20th century progressed, the Nashua River began showing the effects of years and years of pollution. During the 1960s, some sections were so polluted that they changed color almost daily, due to dyes released from paper production. By 1965, the Nashua had become one of the dirtiest rivers in the country, classified U (unfit to receive further sewage). Sewage worms were the most prevalent form of aquatic life, and the river's stench made the land along its banks almost worthless.

Fortunately, this situation has been turned around due in large measure to the vision of Lancaster's Bill Farnsworth, who in 1962 initiated the Nashua River Study Committee and then joined with Marion Stoddart of Groton on the Nashua River Cleanup Committee. The vision was twofold: clean the river and protect the land along its banks. In 1969, the Nashua River Watershed Association was formed. Some 36 years later, more than 8,000 acres of land throughout the watershed and 85 miles of greenway along the riverbanks have been permanently conserved, improving the quality of life for everyone.

Over the past century, Lancaster residents have enjoyed many of the pleasures of small-town life, as will be seen on the pages to come. Though change is inevitable and the pressing challenges of new development loom ahead, the town, with its scenic beauty and a strong sense of community spirit, is still a very pleasant place to live.

One

A PICTURE-PERFECT PLACE

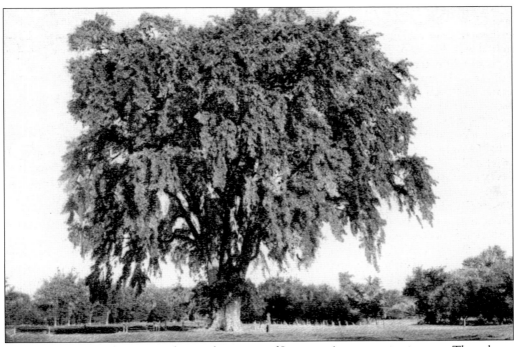

LANCASTER ELM. This postcard view shows one of Lancaster's most majestic trees. Thought to be the largest elm in New England, it was located on Lover's Lane, near the Nashua River in the Five Corners area of town. Unfortunately, the tree, a popular tourist attraction, blew down in 1907.

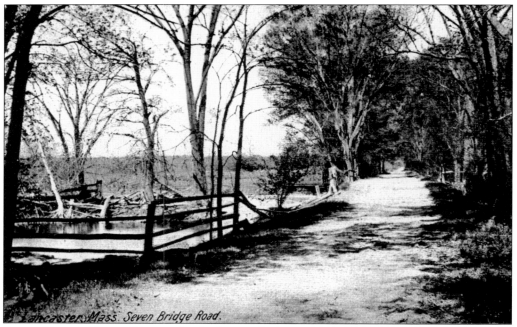

SEVEN BRIDGE ROAD. This road, which actually has seven bridges, was built sometime after 1800 as a toll road or turnpike. It was not accepted as a town road until years later. This view of what is present-day Route 117 shows some very low land on the Nashua floodplain.

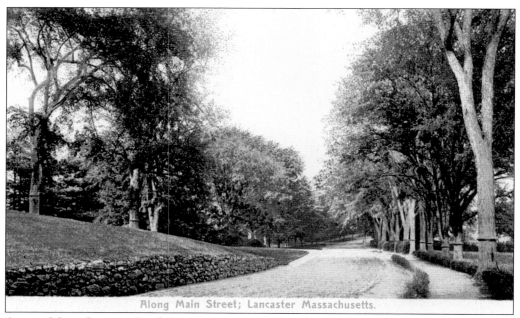

ALONG MAIN STREET. South Lancaster is revealed in this northward view along Main Street. Though not shown, the Thayer family's "Red House," demolished about 1935, was situated on the rise of the hill to the left when this card was printed about 1900. The headquarters for the Atlantic Union Conference of Seventh-Day Adventists has been located on the spot since 1964.

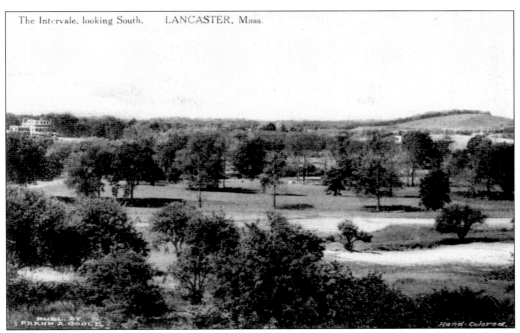

The Intervale, looking South. LANCASTER, Mass.

INTERVALE, LOOKING SOUTH. A sweeping view of the land south of the Nashua River is shown here. This meadowland was called "the Vale of Beauty" by early Lancaster resident and writer Julia Fletcher Carney, who grew up in Woodbine Cottage (no longer standing), located just south of the Nathaniel Thayer residence, which is visible in the upper left.

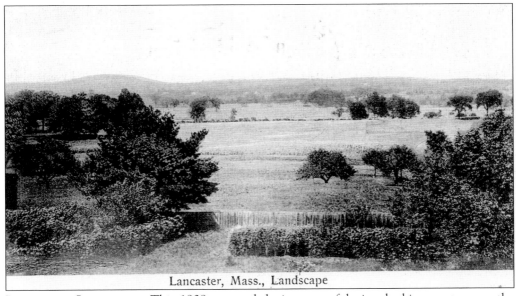

Lancaster, Mass., Landscape

LANCASTER LANDSCAPE. This 1908 postcard depicts a restful view looking west across the intervales, with the George Hill Range in the background.

11

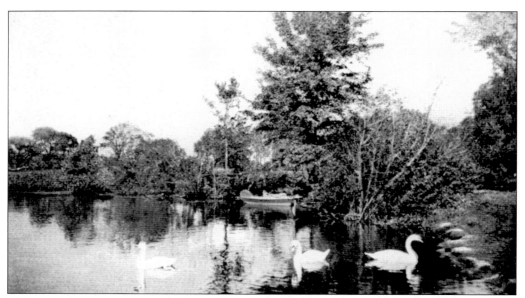

THAYER SWAN POND. Swans swim on this artificial pond, created to ensure a beautiful view from the Nathaniel Thayer estate.

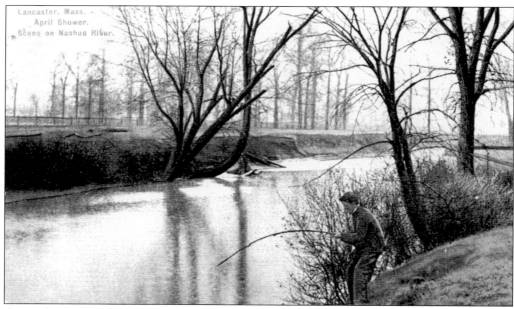

APRIL SHOWERS. A young man pursues the timeless art of fishing along the banks of the Nashua River near the Sprague-Vose Bridge, between Lancaster Center and South Lancaster.

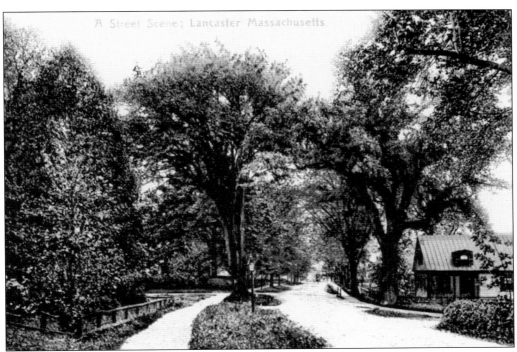

A Street Scene; Lancaster Massachusetts.

STREET SCENE. The unpaved but beautifully landscaped Center Bridge Road heads east toward Bolton. The Joseph Breck home is visible on the right.

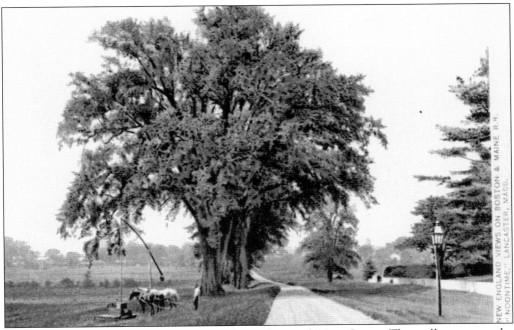

NEW ENGLAND VIEWS ON BOSTON & MAINE R.R.
"NOONTIME," LANCASTER, MASS.

NOONTIME. This view looks west on Neck Road toward Main Street. The well sweep on the left was located across the street from the Charles L. Wilder house (not shown).

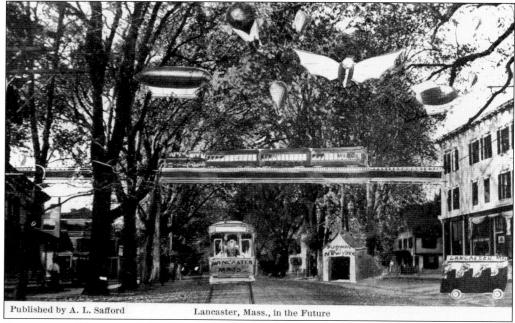

Published by A. L. Safford Lancaster, Mass., in the Future

FUTURISTIC VIEW OF LANCASTER. This card provides a whimsical look into the future of Lancaster Center. The scene occurs in front of the Safford store, formerly located on the east side of Main Street just north of the town green. (TML.)

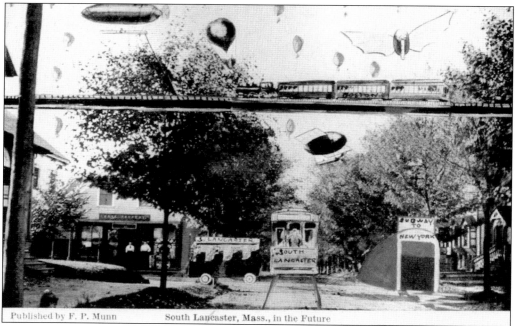

Published by F. P. Munn South Lancaster, Mass., in the Future

FUTURISTIC VIEW OF SOUTH LANCASTER. Another whimsical look into the future for South Lancaster, this scene takes place on Prescott Street near Sawyer Street. (TML.)

14

Two
THE PONAKIN AREA AND NORTH VILLAGE

ANCIENT HOME. This wood-frame home is typical of those located on property taken over by Fort Devens in the late 1930s and 1940s. More than 200 properties were purchased, forcing residents to move.

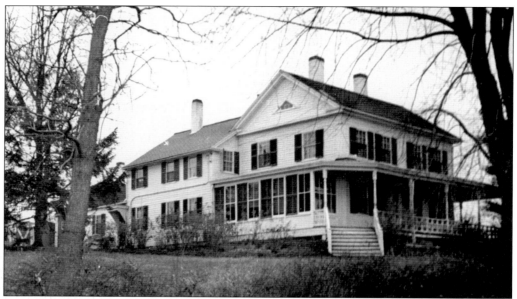

REV. BENJAMIN WHITTEMORE HOUSE. This home was built about 1840 near the top of Ponakin Hill, also called Whittemore Hill. Reverend Whittemore had returned to his native town in 1843 to preach at the First Universalist Church. The church stood in New Boston, then the name of South Lancaster. In later years, the farmhouse, located on Harvard Road, became part of the Goodhue estate and was taken by the government.

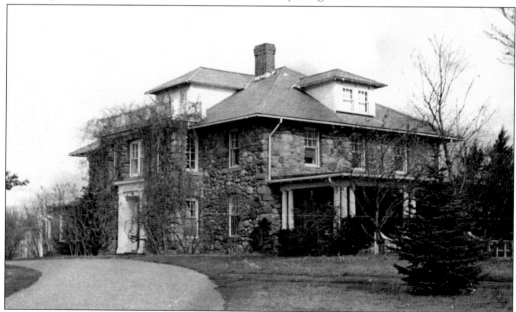

A. F. GOODHUE RESIDENCE. This large stone dwelling was once the summer home of Mr. and Mrs. F. Abbot Goodhue. Mrs. Goodhue was the former Nora Thayer, daughter of Col. John E. Thayer. The picturesque setting included a front entrance directly facing Mount Wachusett and a back entrance facing the Bolton hills. The home stood on Fort Devens reservation land and was the last to be demolished, in 1947.

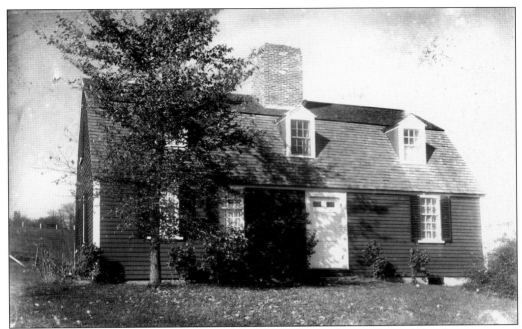

LITTLE RED HOUSE. Dating from c. 1730, this home, located near Harvard Road, was restored to excellent condition by F. Abbot and Nora Goodhue before the surrounding land was taken by the government. The building was then dismantled and re-erected in Lincoln, Massachusetts.

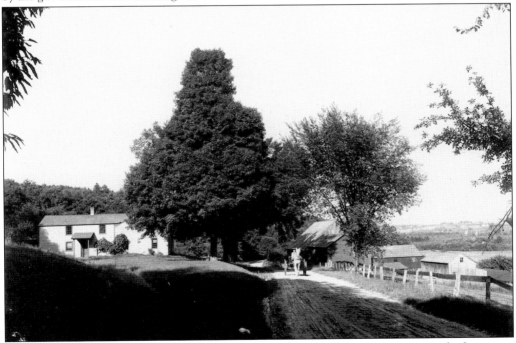

IDYLLIC ROADWAY. The Carr Farm is shown around 1900. This panoramic view looks east to Still River on the Harvard Road, beyond the corner of Schufeldt Road and the Burbank home. The land is on the current North Post.

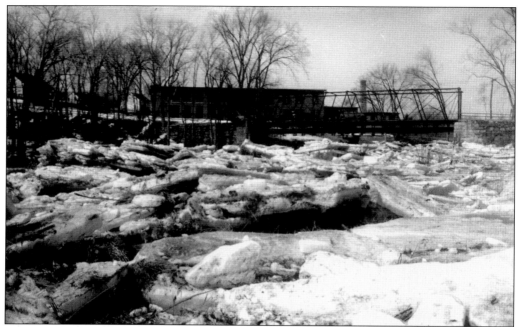

PONAKIN BRIDGE. Built in 1871, the Ponakin Bridge appears here with an ice-clogged North Branch of the Nashua River in the foreground. The bridge still stands but is no longer in use. The Native American word *Quasaponikin* is said to mean "entirely full of water."

JANE RICHARDSON HOUSE. This dwelling, located near the entrance to Ponakin Road, was built about 1840 in the Classic Revival style by George K. Richards. In more recent times, the property belonged to Jane Richardson. A registered nurse, she was a Lancaster town official for many years, serving as an overseer of the poor and on the board of public welfare. After a fire in the mid-1900s, the outer appearance of this house was greatly altered.

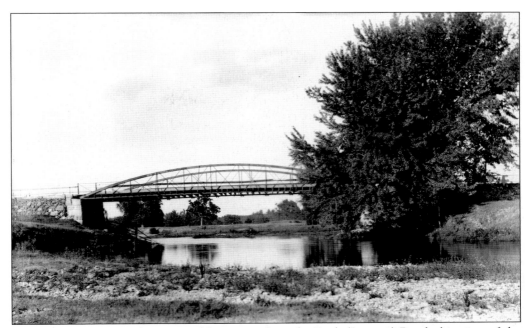

BENNETT BRIDGE. Looking toward Lancaster from the Back (Langen) Road, this view of the Bennett Bridge span was taken in 1890 by Alice Greene Chandler.

NORTH VILLAGE VIEW. This view, looking west toward the Bennett Bridge along present-day Route 117, shows the Bennett home on the left and the Ephraim Carter Fisher house on the right.

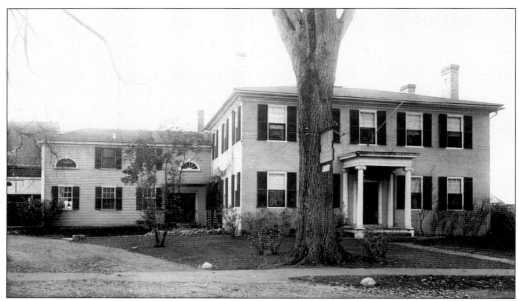

MAJ. JACOB FISHER HOUSE. This impressive Federal-style brick home was built in 1794. Major Fisher, a cabinetmaker from Princeton, no doubt came to Lancaster through his marriage to Nancy Carter, who was from a prominent Lancaster family. A respected and effective leader, Fisher served on many town committees, and his energy and talent promoted the development of business in the area.

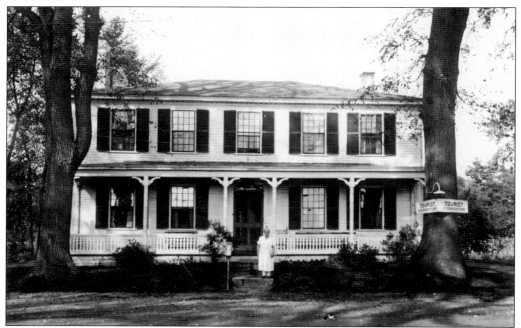

THOMAS HOWE HOUSE. Built in 1809, this large Federal-style house with brick ends was located on North Main Street. The original owner maintained a store and icehouse nearby. In 1817, he sold his home and store to Levi Lewis, who continued to run the business. The store and icehouse have since been razed.

NORTH VILLAGE VIEW. Shown here are, from left to right, the Fairbanks Inn, the Thomas Howe House, and the old Howe store in Lancaster's North Village.

FORMER NORTH VILLAGE HOSE HOUSE. Constructed in 1888, this hose house was first called the C. F. Tufts Fire Company. With the beginning of the cold war in the late 1940s, a Lancaster branch of the Ground Observer Corps of the U.S. Air Force was organized by Berger W. Parmenter and located in this building. The purpose was to maintain vigilance in preparing for a surprise attack from the skies. In 1956, a special observation deck was built on the roof, providing an unobstructed view of the post's area of coverage. Local citizens were encouraged to volunteer for duty. After World War II, the building was turned into a Victorian-style residence.

FORMER LOUISE CHICKERING PRIVATE SCHOOL. In 1947, the Chickering Private School was moved to the North Village from its Lancaster Center location. Louise Chickering, a trained teacher, conducted a kindergarten and grammar school in the house from around 1900 to 1946. In the early years, she could be seen around town picking her students up and bringing them home in her horse and buggy. Today, the building is a private home.

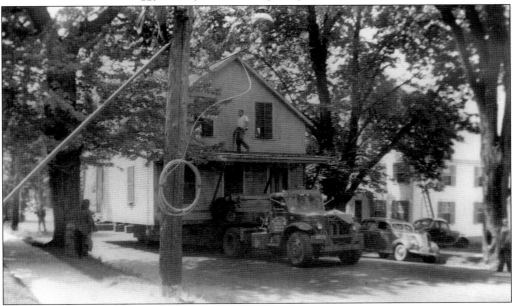

MOVING THAT HOUSE. In years past, moving an entire house from one location to another was not particularly uncommon. This 1947 photograph shows the Chickering Homestead slowly being transferred from the Center Village to the North Village. Tree limbs along the pathway were cut, traffic was rerouted, and business was suspended during the journey, which took about nine hours. (Ponte.)

THOMAS BLOOD HOUSE. At the beginning of the 20th century, this family farm, built around 1845 along Main Street in North Lancaster, consisted of 40 acres of "home farm" and 200 additional woodland acres. The farm produced milk for the Boston market and hay for the local market. W. H. Blood, who occupied the place in the early 1900s, was active in town affairs and lived in Lancaster for more than 50 years. In the early 1970s, a Mr. Hollywood, who then owned the property, sold 28 acres of land to the town for the construction of the new Lancaster Middle School. This photograph shows the remaining farmhouse connected to its barn. This feature was a great convenience for New England farmers when faced with severe winter weather.

Three
CENTER VILLAGE AND THE NECK

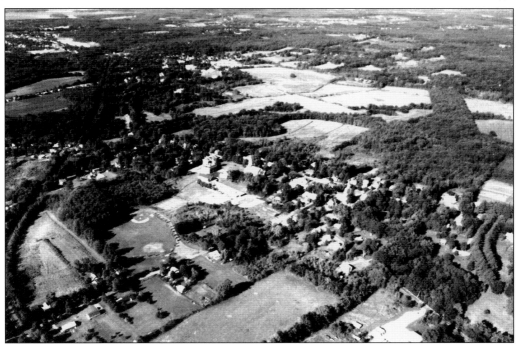

AERIAL VIEW OF LANCASTER CENTER, LOOKING SOUTHWEST. In addition to a view of the town, this 1991 photograph shows the Wachusett Reservoir (upper left corner) and the railroad line from the south (upper left) to the east (lower left). The pilot was Don Crossman. (Farnsworth.)

NEW LANCASTER POLICE STATION. Moving into its new facility was "like night and day" for the Lancaster Police Department. In 2001, the police, who had formerly been housed in the adjacent public safety building, finally had their own building. The dispatchers were moved in also, allowing the facility to be open 24 hours a day for the first time in town history.

JANEWAY EDUCATION CENTER. This building, located on the campus of Lancaster's Dr. Franklin Perkins School, was named in honor of the Janeway family, a longtime benefactor of Perkins. The Janeway Education Center, a spacious state-of-the-art building, opened its doors to students in September 2002. Here, every child learns and grows in an enriched, supportive environment. The center contains a 220-seat auditorium, a dining room, a library, and 15 classrooms.

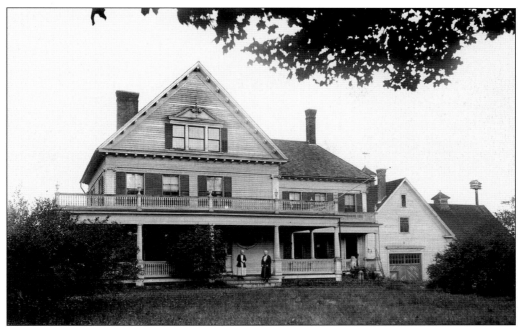

NELSON TRUE HOUSE. Displaying Classic Revival features, this home was built in 1898 by Nelson True. When the True son disappeared while at boarding school, his sister Addie kept a light burning in the family's Lancaster home each night for many years, hoping he would return, but he never did. The house fell into disrepair midcentury but was beautifully restored in 1965.

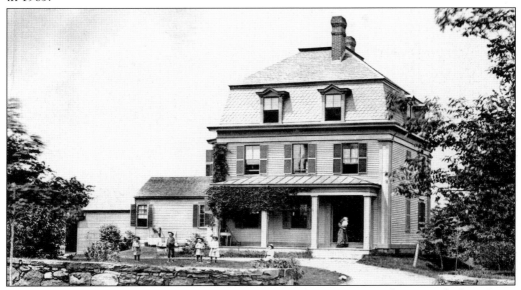

JAMES CARTER HOUSE. A house built by James Carter saw several owners before Anna Whitney, a teacher who had retired from Lancaster High School in 1889, bought the property and did extensive work, giving the house in this image its very Victorian appearance. It is also located on the site of the garrison where, in 1692, American Indians attacked members of the Peter Joslyn family.

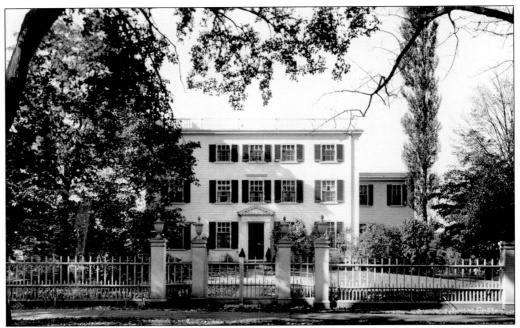

MURRAY POTTER HOUSE. In 1909, Murray Potter of Cambridge bought a brown-shingled Victorian house on Main Street that had been constructed about 1895 by Elizabeth Dix. Potter then had the house rebuilt as a copy of the Pierce-Nichols House in Salem. The Pierce-Nichols House, built by master wood carver Samuel McIntyre, is frequently referred to as the most elegant of his Salem houses. This building is now part of Lancaster's Perkins School.

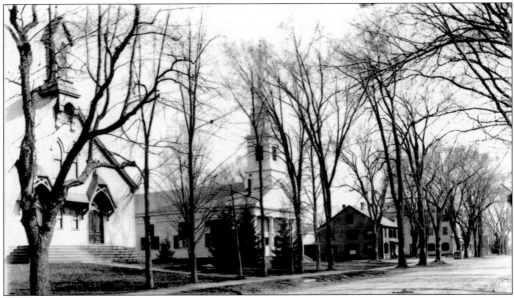

CHURCHES IN LANCASTER CENTER. This early view down Main Street shows the Immaculate Conception Church (left) and the Evangelical Congregational Church (center) as they appeared in the 1890s. Both buildings were subsequently destroyed by fire (in 1941 and 1950, respectively) and then rebuilt.

NEW IMMACULATE CONCEPTION CHURCH. After the earlier building was tragically lost to fire on October 15, 1941, a new church was built in the same location just two years later, though without a steeple. When the 32-foot-high steeple atop the Christmas Tree Shoppes in Olde Shrewsbury Village on Route 9 was removed in 1994, it was donated to the Immaculate Conception Church.

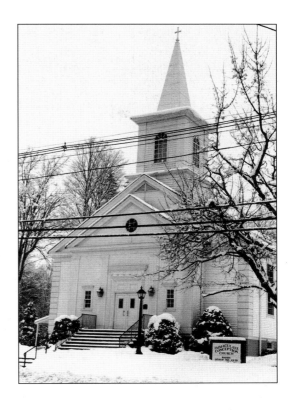

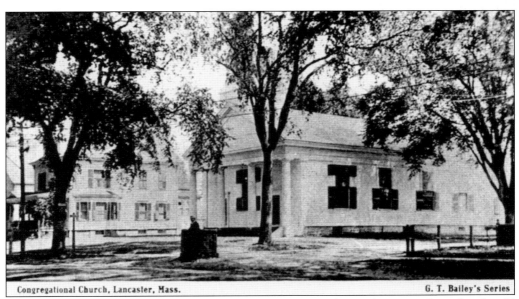

Congregational Church, Lancaster, Mass. G. T. Bailey's Series

OLD CONGREGATIONAL CHURCH PARSONAGE. This postcard view shows, on the right, the old Congregational church parsonage. Built in 1907, it withstood the Hurricane of 1938 and later church fires on either side. The building was, however, demolished in 1977.

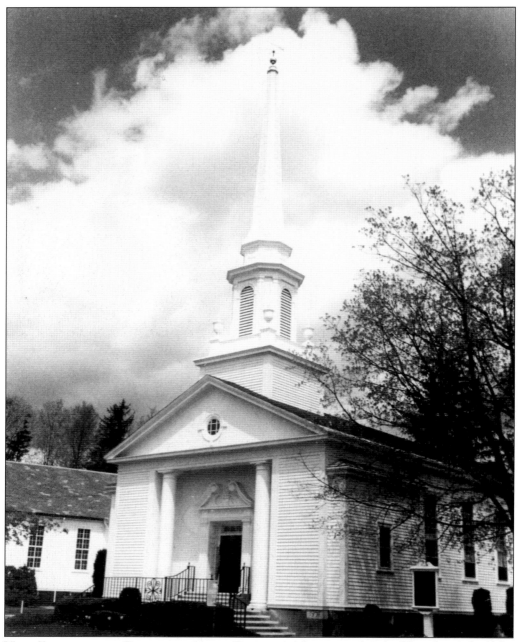

New Evangelical Congregational Church. After its earlier building burned to the ground on a cold night in March 1950, the congregation quickly rebuilt, holding the first worship service in the new structure on October 14, 1951. (Watson.)

FIRST CHURCH OF CHRIST. This classical building is shown here as a postcard by Lancaster photographer James MacDonald.

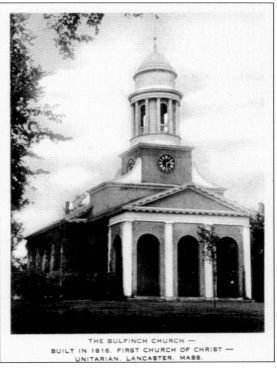

THE BULFINCH CHURCH —
BUILT IN 1816. FIRST CHURCH OF CHRIST —
UNITARIAN. LANCASTER. MASS.

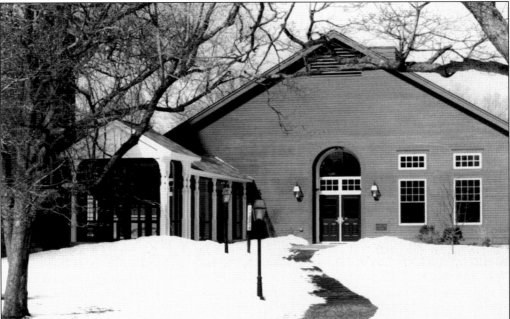

ADDITION TO THE FIRST CHURCH OF CHRIST. Built to meet the needs of an expanding congregation, this 3,500-square-foot addition to the old "Brick Church" was completed in 2002. It connects to the main part of the church by a glassed-in walkway and contains three classrooms, two handicapped-accessible restrooms, and a kitchen-social hall.

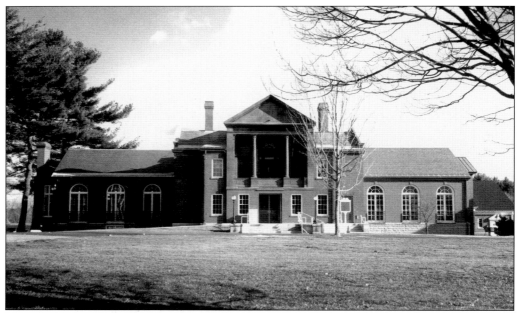

THAYER MEMORIAL LIBRARY. This view includes the newest south wing addition, completed in 1999 and now housing a large reference and study area. The older north wing for the children's department was provided in 1929 through the generosity of Ruth Simpkins Thayer in memory of her deceased son, Nathaniel. (TML.)

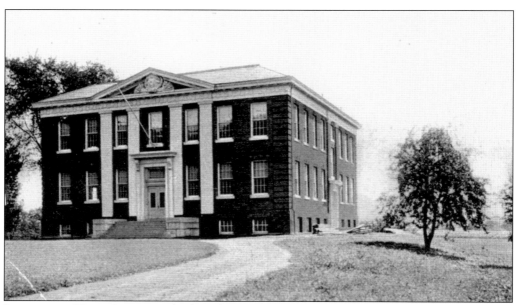

LANCASTER HIGH SCHOOL. The brand-new high school, built in 1903–1904, is shown here before the new town hall was constructed. The building was used as a high school until the consolidated Nashoba Regional High School opened in 1961. Today this building is unused.

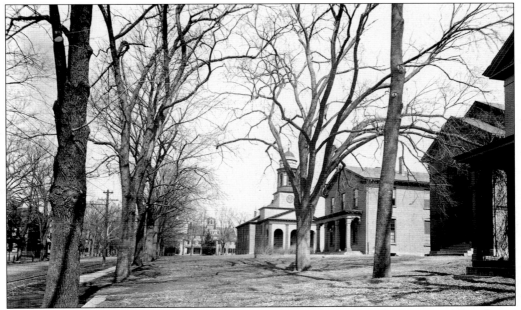

OLD LANCASTER CENTER. This *c.* 1900 photograph provides a view of the area on Main Street that would become the new town green. In the distance is the old Lancaster Hotel. Next, from left to right, are the fifth meetinghouse, the old town house, the Lancaster Academy Building, and the MacDonald home, later moved to Carleton Place.

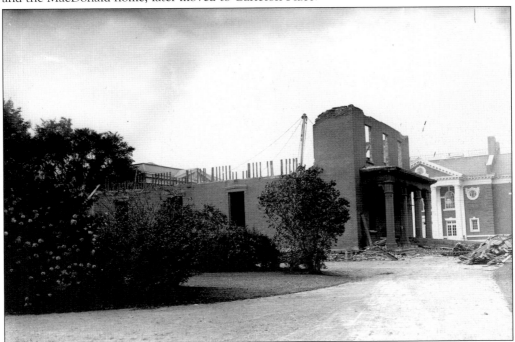

TAKING DOWN THE OLD TOWN HOUSE. The old town house, shown here, was built in 1848. In the background is the new town hall, dedicated in 1908. With the demolition of the old building, the arrangement of the town green was complete.

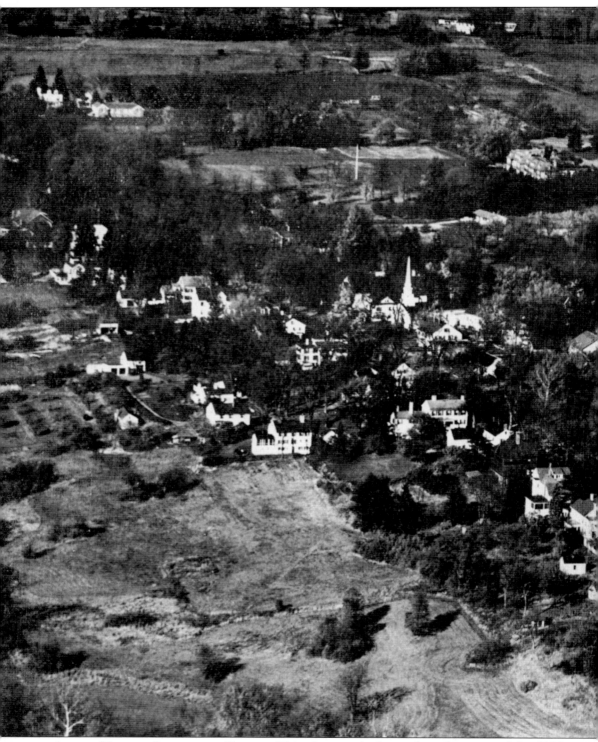

Aerial View of Lancaster Center. This photograph, featured on the cover of the 1955

Lancaster REPORTS 1955

town report, gives an interesting view of this area of town.

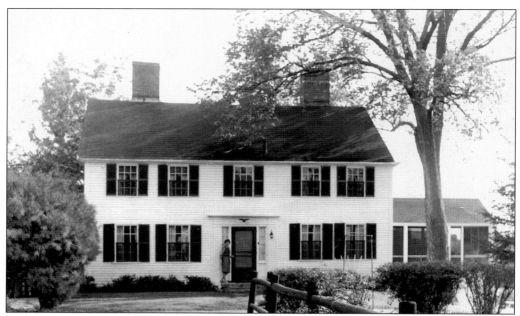

CARTER AND ANDREWS TENANT HOUSE. Carter and Andrews built this Barnes Court tenants' house in 1832, just two years before the publishing company failed. This photograph shows the house as it looked in 1963. Ruth Evans, who owned it at the time, stands to the left of the front door. (Sczerzen.)

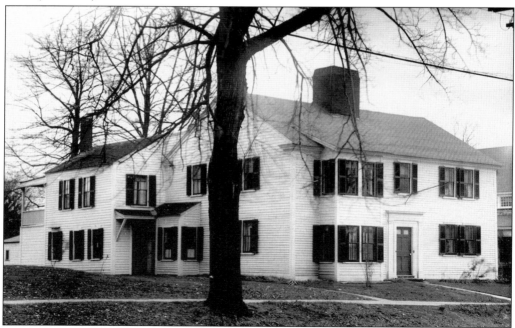

TIDD-CARLETON HOUSE. This *c.* 1750 home is located on Main Street at Carleton Place, south of the town hall. Benjamin Tidd was a baker with a huge fireplace and kitchen ovens, which still remain in the house. When Rev. Nathaniel Thayer first came to Lancaster in 1793, he stayed here until other accommodations were arranged.

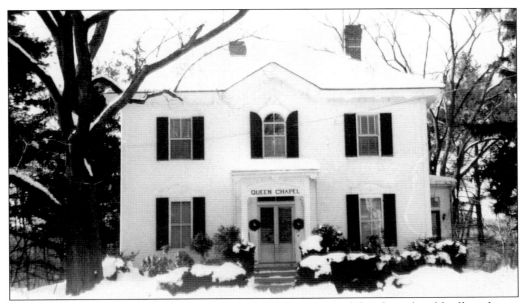

ABBEY CARTER LANE HOUSE. Perhaps the noise of the trains and dust from the old toll road were too much for Mrs. Anthony Lane, for right after the death of her husband in 1869, the widow built herself a lovely new home on Main Street in the center of town. In more recent times, the home has become Queen Chapel, run by longtime Lancaster funeral director Jessica Queen.

DR. J. L. S. THOMPSON HOUSE. Located at the corner of Neck Road and Main Street, this home was long ago occupied by Dr. Thompson, who had moved from Bolton to Lancaster in 1846. Thompson, serving as the town clerk in 1860, was active in town affairs. In more recent times, the home was owned by Anna Codman of Boston, who inherited it from her father, George W. Wheelwright.

NECK ROAD VIEW. This 1893 photograph shows a small, nicely landscaped park at the intersection of Main Street and Neck and Center Bridge Roads. In the background are several of the lovely old homes west of the railroad tracks.

JOSEPH ANDREWS HOUSE. This dwelling, located on Center Bridge Road, was built for Joseph Andrews around the time of his 1831 marriage to Thomazine Phillips of Boston. Andrews was engaged in copper- and steel-plate engraving for the Carter and Andrews Printing and Publishing Company, which operated in Lancaster from about 1825 to 1835. When Carter and Andrews failed, the house was repossessed by the builder.

DR. CALVIN CARTER HOUSE. Situated on the corner of Neck and Center Bridge Roads, this house was built in 1840 by Dr. Calvin Carter, a widely known, successful surgeon in his day. The porch, added later, somewhat hides the Greek Revival features of this dwelling.

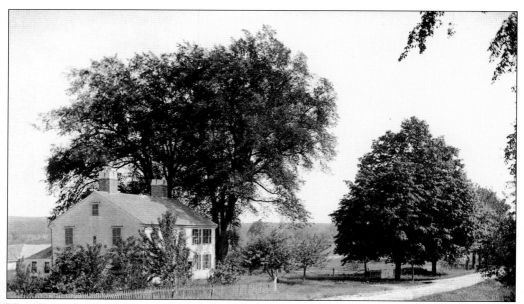

HON. JOHN SPRAGUE HOUSE. This fine old Colonial on Neck Road was the first Lancaster home built by John Sprague, an attorney who moved to the town in 1770 to open an office in partnership with Abel Willard. Sprague, who later became a prominent judge, was active in town affairs and built a second home on the west side of Main Street along the Nashua River.

CHARLES H. LATHAM HOUSE. Located on Neck Road near the end of Packard Street, this Queen Anne–style house was built to be occupied by Charles Latham and his new bride, Lydia S. Frost. The couple was married in Lancaster by Rev. G. M. Bartol in September 1886, and their new home was finished in October of that year. Latham operated a poultry farm and was said to be well known among dealers in fancy birds.

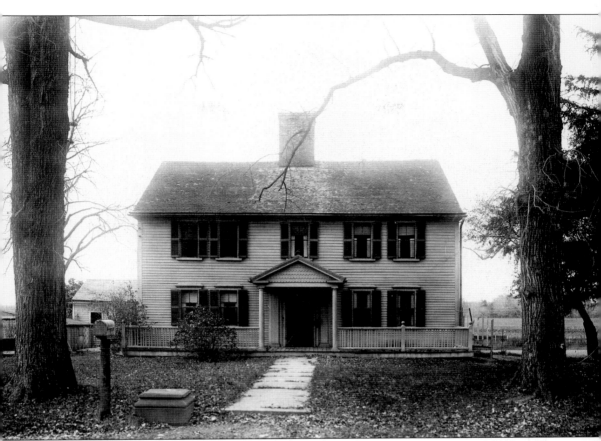

NATHANIEL WYMAN HOUSE. This old Neck Road home was built around 1742. Nathaniel Wyman occupied the house from 1742 to 1776, and it was the birthplace of no fewer than six successive generations of his family. In the left foreground is a base from a portico column of the 1848 town house. It was transported from the town green after the building was razed, around 1907.

WYMAN BARN. The barn near the Wyman house was built in 1743 using some timbers from Lancaster's third meetinghouse, which had stood on the old common since 1706. It was torn down when the fourth meetinghouse was built, in 1742–1743.

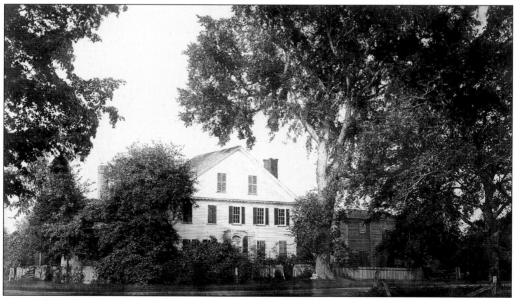

CAPT. ANTHONY LANE HOUSE. This house, located on the northeast corner of Harvard and Seven Bridge Roads, was built by gentleman farmer Anthony Lane in 1809. He also built a cabinet factory on the northwest corner about 1832 and was known as a man of enterprise and influence in both town and church affairs.

Four

SOUTH VILLAGE AND THE DEERSHORN DISTRICT

ELM GROVE. This view shows the corner of Main Street and George Hill Road as it looked around 1879. About that time, the Thayer family acquired the property, building Fairlawn on the site shortly thereafter. The Fay residence, seen in the background, was later moved to George Hill. Many of these elm trees were preserved by the Thayer family. This area may have been part of the "Elm Grove" referred to by early settlers. (TML.)

John Greene Chandler Memorial. This building was originally in the complex of the Lancaster engraving and printing firm of Carter and Andrews. In 1965, Herbert Hosmer moved it to a spot in back of his George Hill Road home, where it served as a museum for his antique children's books, dollhouses, and cut-out toys. To suit his purposes, he created a unique structure incorporating some details from other Lancaster houses. John Greene Chandler (1815–1879), for whom the museum was named, was a wood engraver and lithographer who created items for children. The building is still on the site, but the museum no longer operates. (Schumacher-Hardy; photograph by Paul L'Ecuyer.)

HERBERT HOSMER HOUSE. Located on East George Hill Road, this home was built in 1957 by well-known town historian Herbert Hosmer. In building it, he incorporated materials from his former residence, the Capt. Samuel Ward House, which had been sold and torn down to make way for a new men's dormitory, Lenheim Hall, at Atlantic Union College. (Schumacher-Hardy; photograph by Paul L'Ecuyer.)

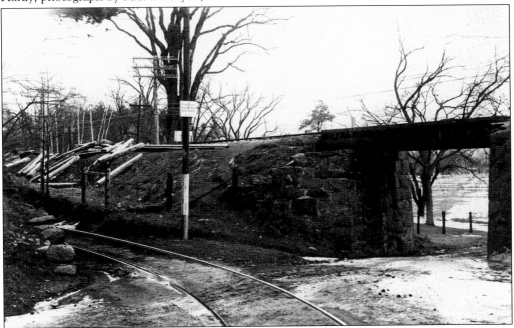

HUMPHREY BRIDGE. This snowy view, looking east on Bolton Road, shows the Humphrey Bridge with the electric car track in the foreground. Eugene V. R. Thayer had the track diverted to prevent electric cars from passing in front of the Thayer estates on Main Street on their way from Lancaster Center to South Lancaster.

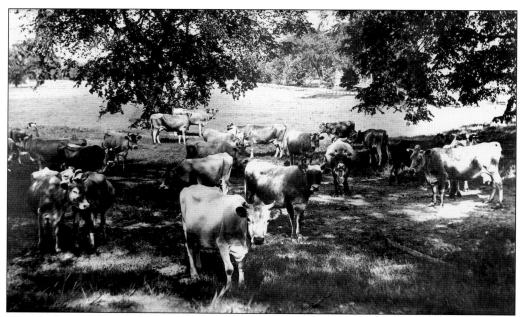

CATTLE ON BOLTON ROAD. Some of Pauline Revere Thayer's special Jersey cows peacefully graze on Thayer pastureland east of the Humphrey Bridge. (Kilbourn.)

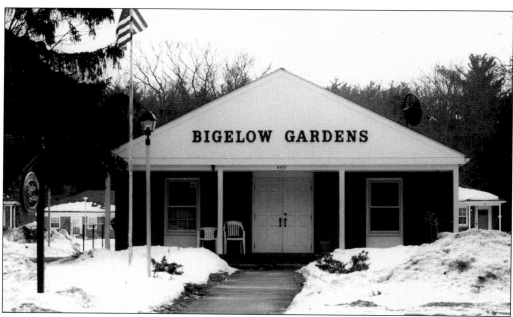

BIGELOW GARDENS. One of the greatest social projects ever undertaken in Lancaster was completed in 1961. The housing for the elderly state-aided project was called Bigelow Gardens. The dedication service was held on July 25, 1961, and by September of that year, all the new apartments were rented. Today, the complex has a total of 70 housing units. It is located on the site of the English gardens that were part of the Nathaniel Thayer estate.

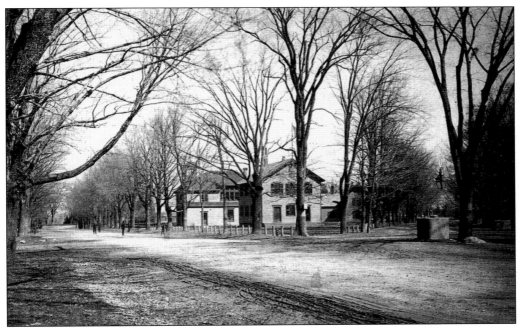

MAIN STREET AND BOLTON ROAD. This late-19th-century view shows the unpaved intersection of Main Street and Bolton Road, with the South Lancaster Hose House and the Ward Park School in the center.

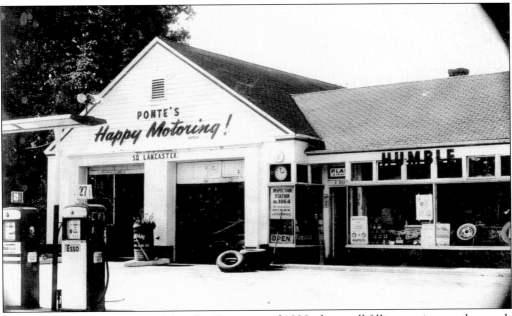

PONTE'S SERVICE STATION. After the Hurricane of 1938, the small filling station on the north corner of Main and Prescott Streets was replaced by this larger one built on the south corner. Later, Lancaster resident Frank Ponte operated his business on the site for 27 years, until 1972. This photograph shows the station as it looked in 1965. Note those low prices on the gas pumps. (Ponte.)

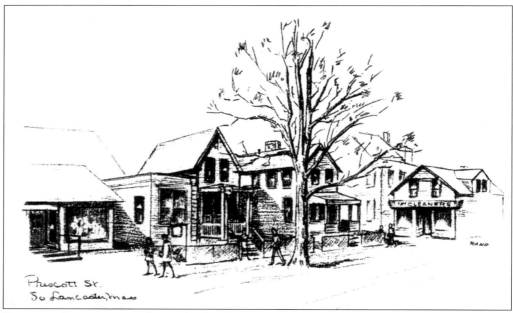

PRESCOTT STREET VIEW. The south side of Prescott Street in South Lancaster, shown here, looked much the same for several decades in the 20th century. The print is by Herbert L. Rand. (AUC.)

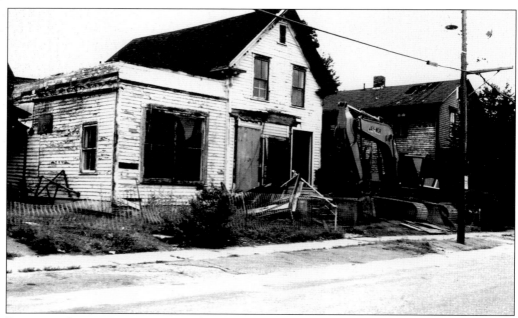

PRESCOTT STREET DEMOLITION. When they were demolished (after 1987), the Prescott Street buildings, which had outlasted their usefulness, were reportedly to be replaced with new student housing for Atlantic Union College. Today, however, the land is still open space. A building in the back of the complex was the original schoolhouse for South Lancaster Academy. Its condition was so poor that it could not be salvaged. (Hart.)

STARBUCK HOUSE. This gardener's cottage, located at the corner of Bolton Road and Main Street, was occupied by the English-immigrant Starbuck family. Charles Starbuck worked for the Thayer family for 45 years as a butler for Eugene V. R. Thayer and then for his son Eugene V. R. Thayer II, whose banking career took them to New York City. Starbuck's daughter Katherine lived in the house until her death in 1973.

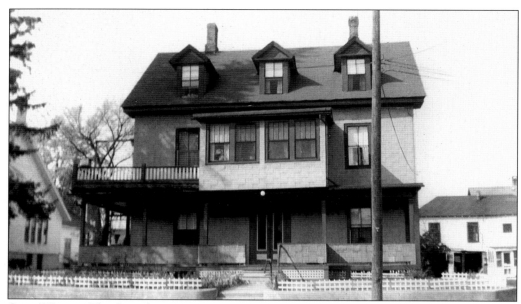

CADY HOUSE. This large house, across from the post office on Sawyer Street, was purchased by Advent pioneer S. N. Haskell around 1873. When occupied by his secretary, Irene J. Cady, it held many apartments. In 1973, this house and several other buildings on the block were demolished to provide parking space for the Village Church of Seventh-Day Adventists. (Ponte.)

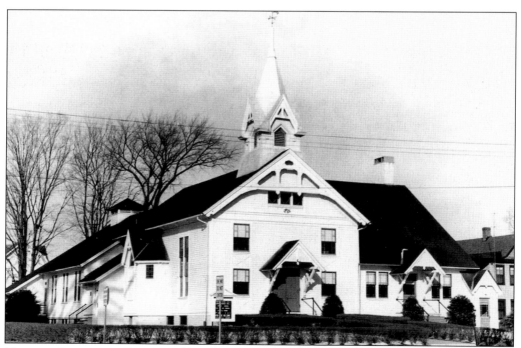

VILLAGE CHURCH OF SEVENTH-DAY ADVENTISTS. This building was originally constructed in 1878 and has had many additions. The last was a fellowship hall on the north end, added in 1978. This view of the church is from the mid-1960s. (AUC.)

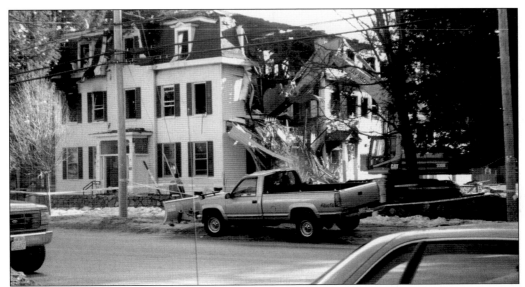

ROSS MANOR. Burgess Ross and his wife, Hallie Snyder Ross, who had both taught at Atlantic Union College in the 1920s, purchased the former Howe estate on the east side of Main Street in South Lancaster. They improved the place, adding to it and developing a garden with a large greenhouse. Around 1948, the Rosses sold the estate, with its 16 apartments, to the college. Through the years, it continued to be used for student housing. Unfortunately, the building was lost to fire on February 11, 2000. (Ponte.)

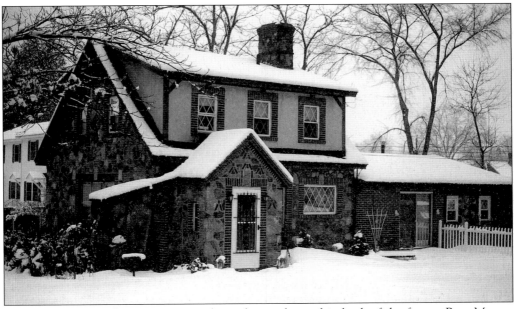

ROSS RESIDENCE. The stone cottage shown here is located in back of the former Ross Manor. It was built by Burgess and Hallie Ross for their own use. When they sold the property to Atlantic Union College, college president Lewis N. Holm occupied the home.

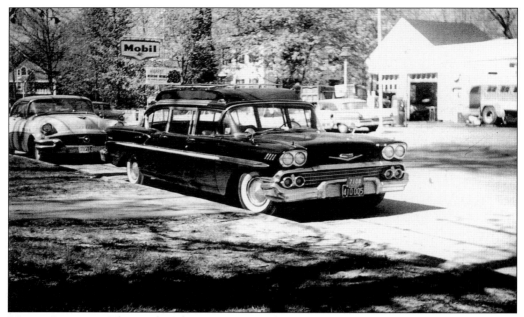

MOBIL STATION. This mid-20th-century view shows Main Street in South Lancaster. The Mobil station on the south corner of Main Street and Narrow Lane was operated by Lancaster resident Chet Tulowiecki. A nicely landscaped garden now occupies the spot. Note the 1958 Chevy. (Ponte.)

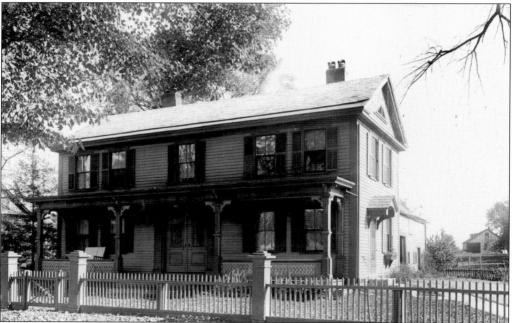

STRATTON HOUSE. Built in 1895, the Stratton House is located on the east side of Main Street, just south of Ross Manor in South Lancaster. The Strattons were associated with Lancaster's Eager and Stratton Pump Company. More recently, the property has been used for Atlantic Union College housing.

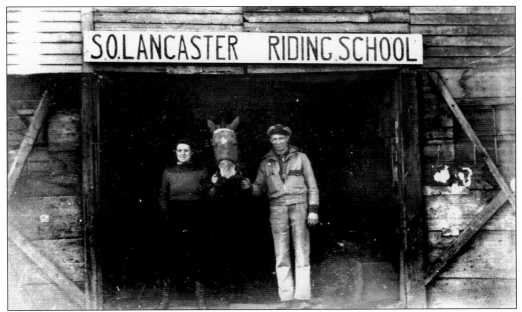

SOUTH LANCASTER RIDING SCHOOL. In the late 1930s, the South Lancaster Riding School, operated by Henry (Hank) St. Jacques, was located near the Southern New England Conference Office on Sawyer Street. Shown here are Hank's sister Alice St. Jacques Mason and Hank. (Laurence.)

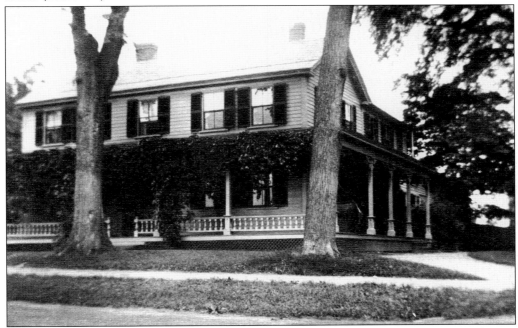

BANCROFT HOUSE. This photograph, taken in 1911, shows the home of Andrew and Mary Ann Bancroft. They had four sons: George, Charles, Edward, and William. Their only daughter, Mattie, taught school in South Lancaster. The house is situated on Sterling Road opposite Mill Street.

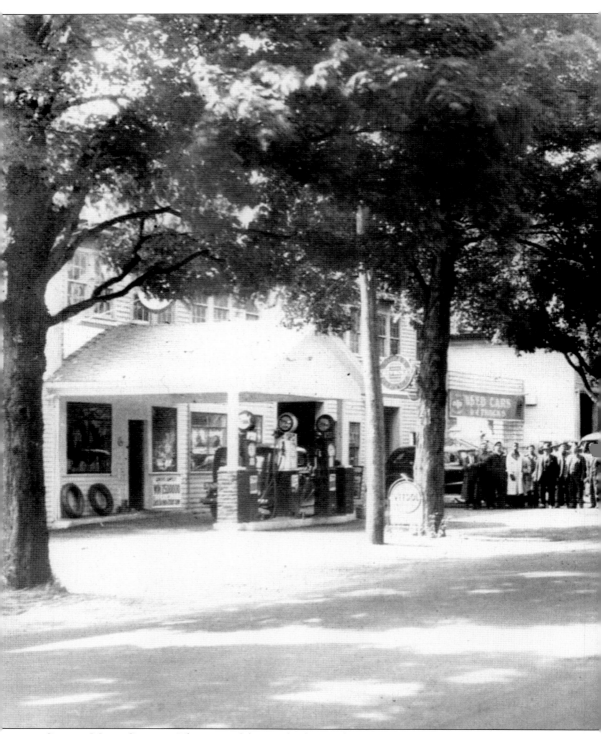

SOUTH MAIN STREET. This peaceful view looks north on Main Street in South Lancaster, likely in the early 1940s. The dusty dirt road of earlier times has now been paved. The Tydol

filling station on the right, operated for many years by Glenn Bowen and Fred Willruth, is now the site of a Cumberland Farms store. (Christoph.)

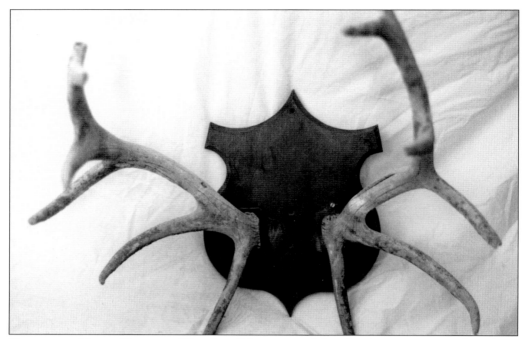

Deershorn Name. The name "Deershorn" (pronounced *deers horn*) came into use after a large horned animal was shot by 16-year-old settler Jonas Fairbanks around 1800. The horns were posted at a place called Sly's Corner, where the two roads to Sterling separate. After marking the spot for nearly a century, the lichen-covered horns were taken to the town's Memorial Hall for preservation. The famous 12-point horns, actually those of an elk, are shown here.

John Gates Thurston House. Long ago, at the parting of the ways to Sterling in the Deershorn district stood the far-famed Gates Tavern, run by father and son Capts. Hezekiah and Thomas Gates. It was later inherited by the Thurston family. The Thurston house, dating back to around 1792, has been occupied by members of the Kilbourn family since 1944.

Five

BUILDING A CAMPUS AT AUC

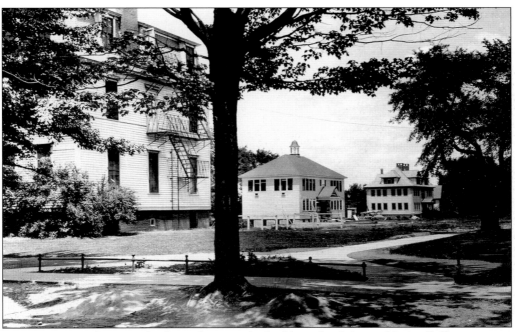

CONNECTING A CAMPUS. In the early years, the buildings for Atlantic Union College were on two separate tracts of land with a garden tract between owned by someone else. In the early 1930s, college president Otto John finally persuaded the owner to sell, making way for E. Edgar Miles Hall. Shown here is the new sidewalk, 600 feet long, from Prescott Street to the steps of what was then the Academy Building. The campus was finally connected. (AUC.)

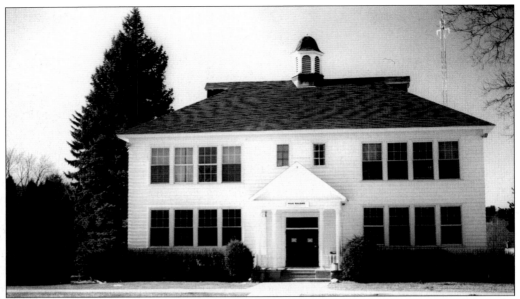

E. EDGAR MILES HALL. Because the school was weak in the sciences and threatened with the loss of accreditation, college president Otto M. John turned to elder E. E. Miles for help in 1931. Miles, who had started a private bindery where students could earn money to work their way through school, provided funds for a new science building with classroom and laboratory space. The school kept its accreditation.

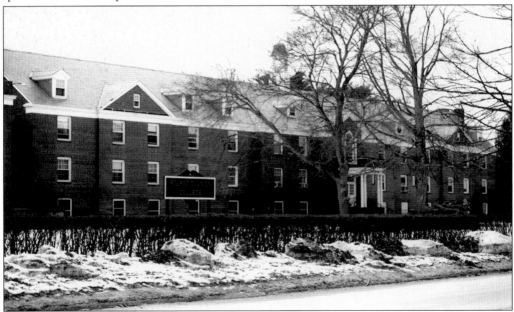

PRESTON HALL. Named for Rachel Oakes Preston, the New Hampshire school teacher credited with bringing the seventh-day Sabbath teaching to the Millerites, this red-brick Federal-style building was part of the college's expansion program under president G. Eric Jones. Started in 1939, it was not completed until 1943. Wings to the south and west were added in 1963 and 1967 to meet increasing enrollment.

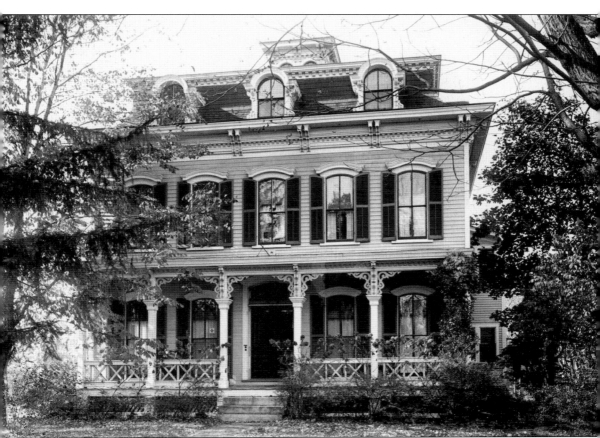

CHANT HALL. This showy Victorian house was built about 1860 by Daniel Goss and was later occupied by Mrs. Charles R. Chant. It was originally located on Main Street in South Lancaster. To make way for Preston Hall in the 1940s, it was purchased and moved back toward Orchard Street. The building has since been used as a music department and as a dormitory. It was reportedly the first prefabricated house in Lancaster.

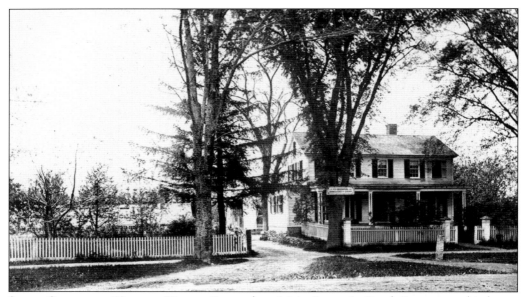

SEARS-CHANDLER-HOSMER HOUSE. Located on Main Street in South Lancaster, this house was the former parsonage of poet and minister Edmund Hamilton Sears, known for writing "It Came Upon a Midnight Clear." Florist G. Frederick Chandler then acquired the property, and it was later inherited by the Hosmer family. In 1944, AUC moved the building to "Faculty Row" on George Hill Road. This view shows the house when owned by G. F. Chandler.

FLOWERS.

1843.

G. F. CHANDLER,

Florist and Floral Decorator,

SOUTH, LANCASTER, MASS.

Greenhouse, Parlor and Garden Plants.

FLOWER SEEDS AND BULBS.

All Kinds of Floral Work and Decorations made to order at short notice.

1892.

WITH CARE.

G. F. CHANDLER BUSINESS CARD. Chandler developed the first commercial greenhouses in Worcester County next to his Main Street home. (Schumacher-Hardy.)

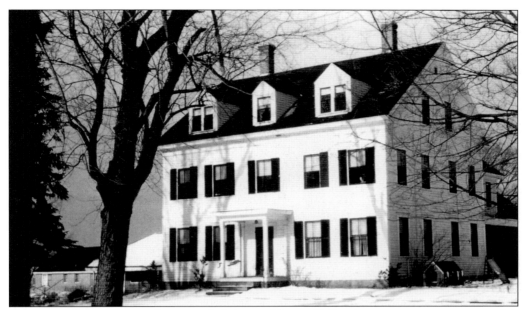

KILBOURN FARMHOUSE. As part of Atlantic Union College's expansion movement, this 16-room farmhouse and about 100 acres of land were purchased in 1942. The old farmhouse, built between 1857 and 1870, then became part of Faculty Row on George Hill Road. (AUC.)

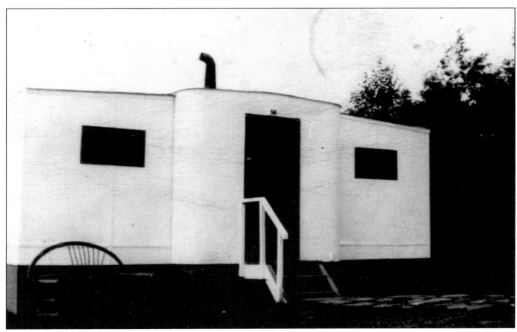

TRAILER VILLAGE HOME. To provide housing for married ex-servicemen enrolling as students, the college purchased 61 trailers from the federal government in 1946. They were placed in rows in the field north of the present-day Thayer Music Conservatory. The trailer village, which had a common bathhouse rather than individual facilities in the units, lasted about five years. Shown here is trailer No. 56, still owned by Frank Ponte. (Ponte, AUC.)

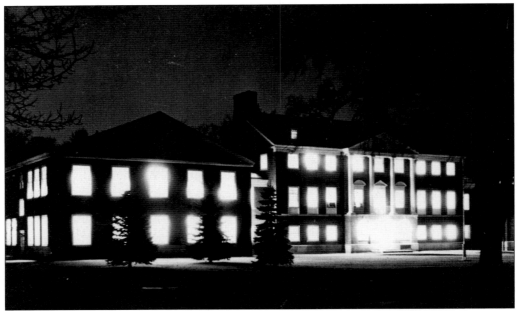

STEPHEN H. HASKELL HALL. Plans had been made for a new administration building as far back as 1938, but due to World War II and a shortage of building materials, the new structure was not completed until 1952. It provided much needed room for administrative offices, classrooms, a library, and auditorium. Shown here is a nighttime view of Haskell Hall. (AUC.)

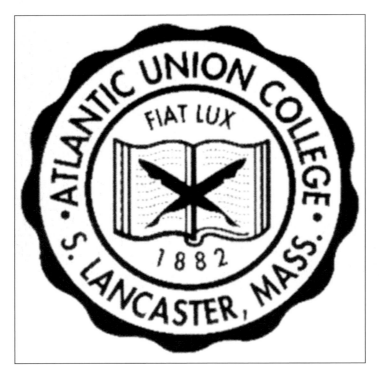

SCHOOL SEAL. On the rotunda floor in the main entrance of Haskell Hall is the school's seal with the phrase *Fiat Lux,* meaning "Let there be light." The words reflect the vision of the school's founder, Stephen H. Haskell, who wanted the light of the gospel to spread to the entire world. (AUC.)

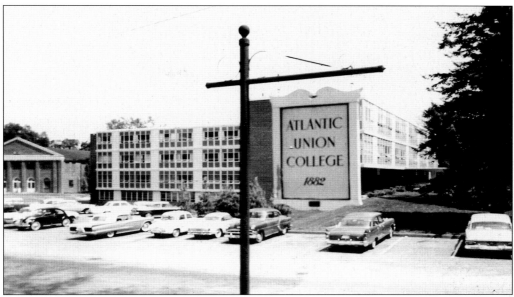

LOUIS E. LENHEIM HALL. To meet the pressing need for a new men's dormitory, president Larry Stump decided to implement building concepts he had seen in California and Southeast Asia during and after World War II. When complete, the building, with its turquoise blue panels around the windows, reflected a modern 1950s look in sharp contrast to other campus buildings. This view, taken from George Hill Road, shows the dormitory in the early 1960s. (AUC.)

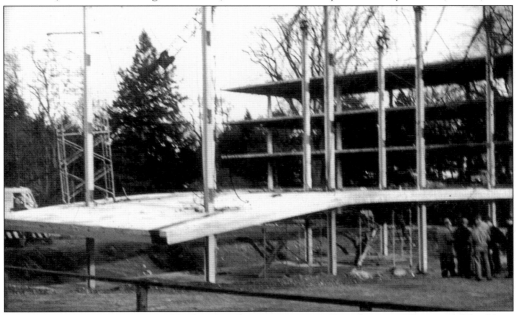

BUILDING TECHNIQUE. By 1955, the new dormitory was well under way. The special building technique required entire floors to be cast in units, then raised and attached to steel beams. One floor unexpectedly collapsed during the process. Though time was lost and finances tight, the building was completed in 1956 and dedicated to Louis E. Lenheim, then president of the Atlantic Union Conference. (Ponte.)

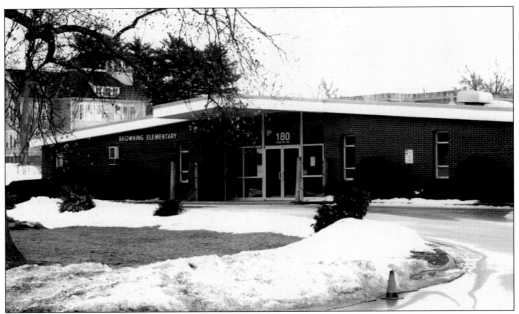

NEW BROWNING ELEMENTARY. By the early 1960s, with plans under way to build a new library on the old Browning Memorial site, the facility shown here had been constructed on George Hill Road. The antiquated Browning Memorial School on Flagg Street was razed and the lower portion of the street closed, creating a quadrangle on the campus.

NEW SOUTH LANCASTER ACADEMY. Since 1882, the academy had shared the campus of Atlantic Union College. By 1967, however, plans were in place and ground was being broken for this new separate facility on George Hill Road. Today, Browning Elementary and South Lancaster Academy serve kindergarten through 12th grade under one principal. The small tower in the right foreground houses the original school bell.

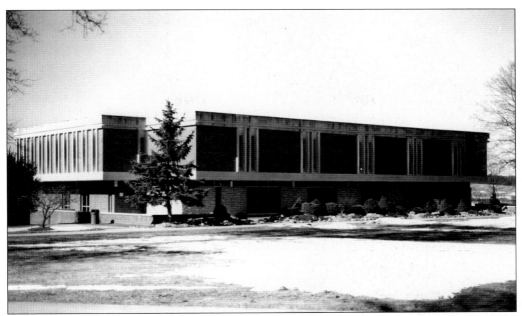

G. ERIC JONES LIBRARY. After being located in cramped quarters in Haskell Hall for nearly 20 years, the library was ready for change. Longtime library director Oscar Schmidt decided on a functional and modern style of building that would blend with the campus. On April 17, 1970, the new library was dedicated with former president G. Eric Jones in attendance.

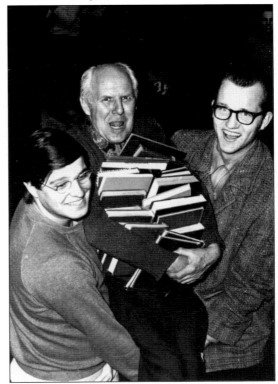

MOVING ALL THOSE BOOKS. One of the biggest jobs upon completion of the new G. Eric Jones Library was the moving of more than 80,000 books. This was accomplished by college students and faculty. Shown here are students Roland Madore (left) and Milton Fish (right), who carried director Oscar Schmidt (center) over the threshold with the last armload of books. (AUC.)

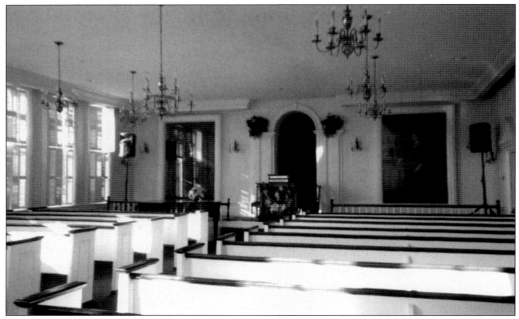

MILLER CHAPEL. In honor of early Advent pioneer William E. Miller, the chapel on the second floor of Founder's Hall was remodeled in the mid-1970s. The chapel was redone in the Federal style because of its use during Miller's lifetime. Seating 200, it contains matching portraits of William Miller and his wife, Lucy, a Millerite 1843 chart, and Miller's pulpit.

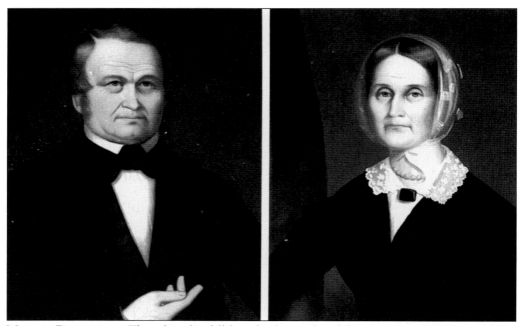

MILLER PORTRAITS. The chapel's full-length, larger-than-life portraits of William Miller (1782–1849) and his wife, Lucy Paulina Miller, were painted by American primitive artist Horace Bundy. Miller had predicted that the second coming of Christ would occur in 1843. (AUC.)

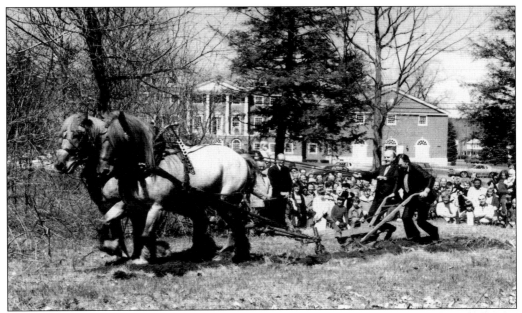

BREAKING THE GROUND. Behind the plow on the left is pastor Stanley Steiner at the groundbreaking ceremony for a new college church on Main Street. Before the church was built, the congregation had been using Machlan Auditorium in Haskell Hall for worship services. (Millet.)

NEW COLLEGE CHURCH. Construction on this contemporary church began in August 1979, and the building hosted its first worship service on May 9, 1981. The 90-foot-high, two-story structure has a seating capacity of 1,250. A special feature in the sanctuary is a tower that allows natural light to reflect down from its walls to the floor, 56 feet below.

CHAN SHUN DINING COMMONS. Completed in 1995, this imposing contemporary facility on Prescott Street was made possible through the generosity of Chinese philanthropist Chan Shun. The main dining area has a seating capacity of 300, and other function rooms include a special president's dining room.

FORMER KILGORE COTTAGE. This quaint cottage was the home of Prof. Rochelle P. Kilgore. Through the years, she provided residence in her home for many foreign students. Today, the Flagg Street building contains the college's offices for alumni affairs, public relations, and advancement.

Six

GLIMPSES OF THE GILDED AGE

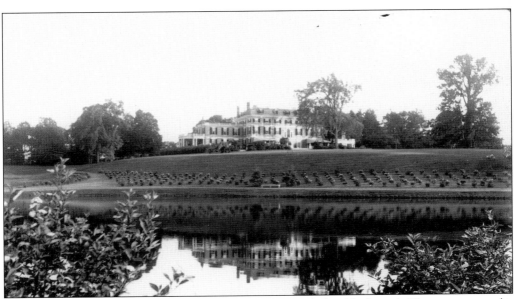

HOMESTEAD MIRRORED IMAGE. The terrace front of the Nathaniel Thayer estate, the Homestead, is beautifully mirrored in this *c.* 1900 view. Note the new plantings along the shore of Thayer Pond. The home had just been enlarged and remodeled by Ogden Codman. The Thayer family frequently commissioned him to work on their many homes.

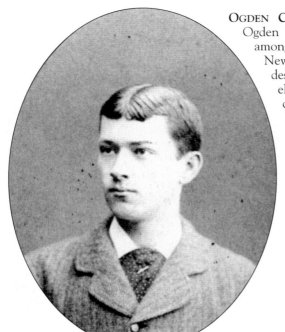

OGDEN CODMAN JR. (1863–1951). Boston-born Ogden Codman Jr. acquired quite a reputation among the cultured and social circles of Boston, Newport, and New York as a top-notch interior designer and architect. He was known for his elegant and restrained interpretations of the classical and Colonial Revival styles. In Lancaster, he was commissioned to work on the Homestead, Hawthorne Hill, and Crownledge. This *c.* 1880 photograph reveals a young Ogden Codman Jr. (SPNEA; photograph by Ordinaire, Dinard, France.)

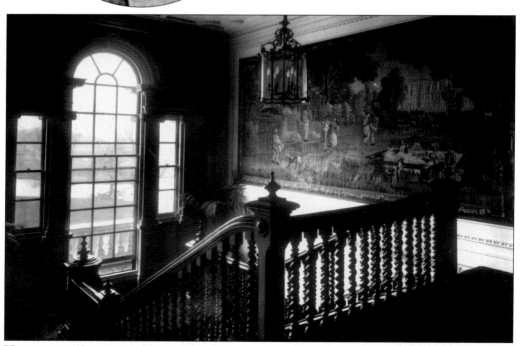

HOMESTEAD ENTRANCE HALL. The floor was of black-and-white marble. The walls were of paneled wood painted white, with pieces of tapestry in the center panels. The red-carpeted mahogany staircase occupying the center hall was the chief feature retained in the rebuilding done by Ogden Codman Jr. It divided beneath a magnificent triple Palladian window. Shown here are the triple window, the tapestry, a portion of the staircase, and ceiling detail.

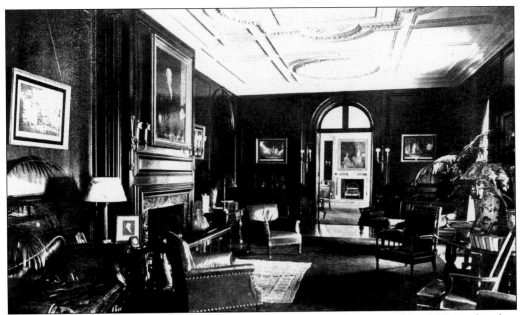

HOMESTEAD GALLERY. This room was paneled in oak to the ceiling. The dark walls made a fine contrast to the deep red of the furniture covering. Above the fireplace was a portrait of John Jay painted by Gilbert Stuart. John Jay had given it to Gen. Stephen Van Rennselaer, father-in-law of Nathaniel Thayer II, who built the Homestead. (TML.)

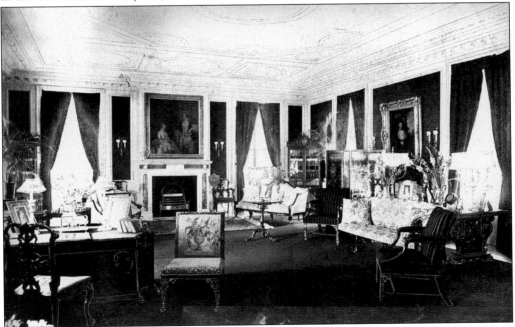

HOMESTEAD DRAWING ROOM. This large rectangular room had white walls with panels of red silk damask encased within molded frames. The curtains were of the same material. The room was filled with a collection of elegant and costly furniture, old English portraits and paintings, and other rare and curious objects. (TML.)

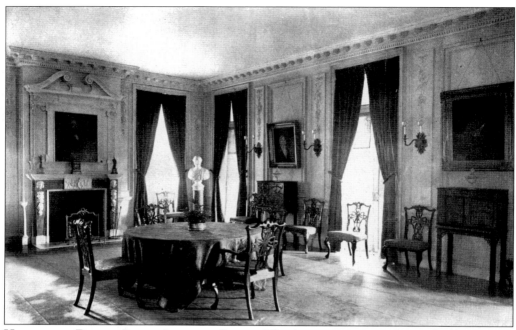

HOMESTEAD DINING ROOM, LOOKING SOUTH. The dining room mantel was of yellow marble with a white marble shelf and ornaments. A large portrait of Nathaniel Thayer Sr. hangs over the mantel; nearby are two marble busts of distinguished Thayer family members. (TML.)

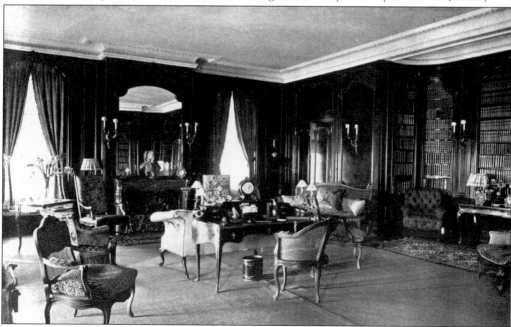

HOMESTEAD LIBRARY. The library was paneled throughout in polished French walnut. The mantel, of red marble, supported a built-in mirror. (Mirrored overmantels with plaster decoration and marble fireplaces were Codman's trademarks.) On one side was an elliptical recess lined with books. The curtains, carpet, and furniture were green. (TML.)

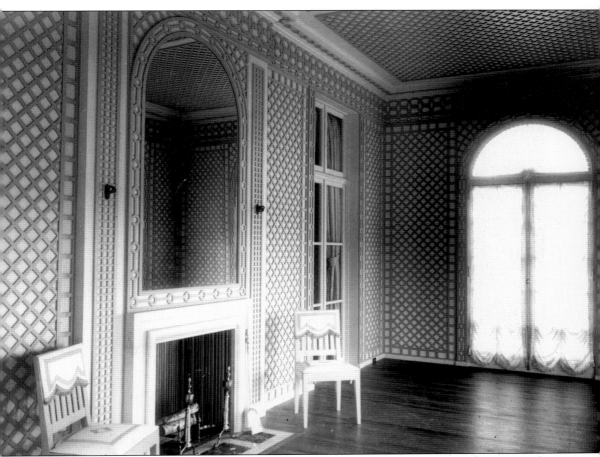

HOMESTEAD SITTING ROOM. This view shows an elaborate green-latticed wall treatment in a room off the master bedroom. The master bedroom itself had walls of French gray and panels with white moldings. The furnishings were white and gray, with curtains of pink damask. The room contained a rose and white marble fireplace surmounted by a large mirror.

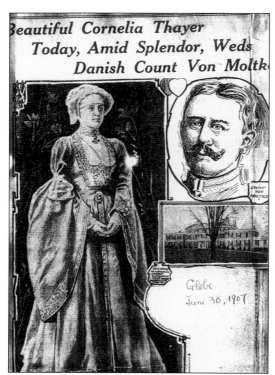

Beautiful Cornelia Thayer
Today, Amid Splendor, Weds
Danish Count Von Moltke

Globe
June 30, 1907

THAYER WEDDING. During the Gilded Age, many American millionaires sought matches for their daughters with eager candidates from Europe's nobility. Such a match was made on June 29, 1907, when Cornelia Thayer wed Count Carl Von Moltke of Copenhagen, Denmark. Nathaniel Thayer III, father of the bride, gave his daughter away in the drawing room of the Homestead. The setting of the ceremony was said to have been modeled after the recent wedding of Teddy Roosevelt's daughter Alice. (TML.)

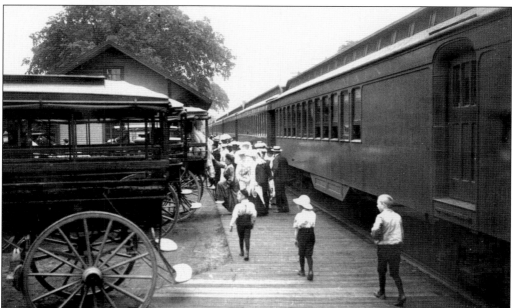

WEDDING GUESTS ARRIVE. Guests arrive at the Lancaster depot for a Thayer wedding. When Cornelia Thayer married, a special train made up of Pullmans was 30 minutes late pulling into the station. So as not to disappoint her guests, who would want to witness the ceremony, the bride graciously insisted upon waiting in her boudoir until she saw the carriages turning into the Homestead.

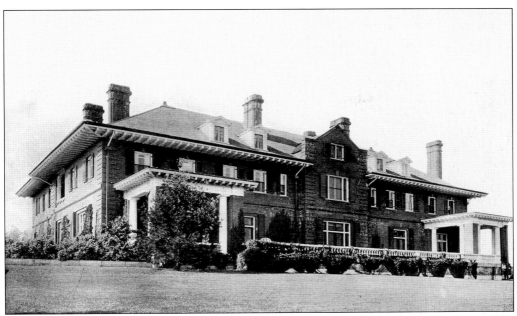

HAWTHORNE HILL LAWN FRONT. In 1906, a series of photographs featuring Hawthorne Hill appeared in a journal called the *Architectural Review*. Since this was right after the estate had been built, it gives some wonderful early views. Shown here is the Lawn Front, which provided a view of the Bolton hills to the east. (TML.)

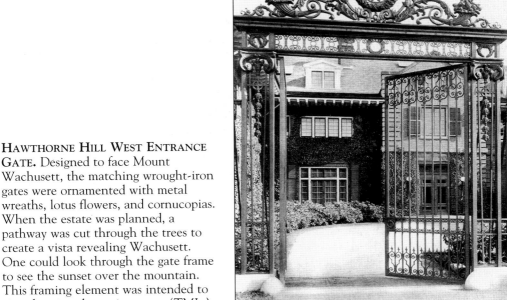

HAWTHORNE HILL WEST ENTRANCE GATE. Designed to face Mount Wachusett, the matching wrought-iron gates were ornamented with metal wreaths, lotus flowers, and cornucopias. When the estate was planned, a pathway was cut through the trees to create a vista revealing Wachusett. One could look through the gate frame to see the sunset over the mountain. This framing element was intended to give the view dramatic power. (TML.)

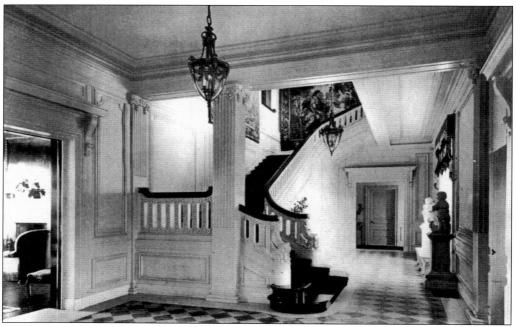

HAWTHORNE HILL WEST ENTRANCE HALL. This spacious entrance hall is dominated by a white curving staircase with balusters elaborately carved in a floral motif. The *Four Seasons* statues, right, are now housed in the Thayer Memorial Library. (TML.)

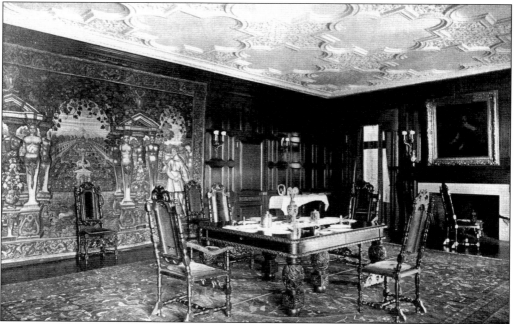

HAWTHORNE HILL DINING ROOM. Note the ceiling detail, ornate furnishings, and the large tapestry on the left. Though impressive in Lancaster, this mansion, at 30,000 square feet, was actually small compared to others of its day. The Breakers, the Vanderbilt cottage in Newport, Rhode Island, is 120,000 square feet. (TML.)

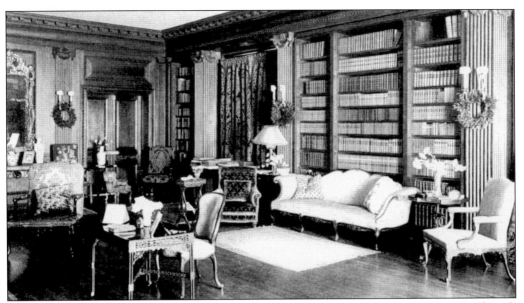

HAWTHORNE HILL LIBRARY. Note the elaborate detail and furnishings of this room. Though the estate was beautiful, Bayard and Ruth Thayer, who lived in a stylish townhouse on Beacon Street in Boston (which later became well known as the setting for *Cheers*), spent only limited amounts of time in Lancaster. They would arrive in May for a brief visit and then return in the late summer or fall for the hunting season. (Phillips.)

HAWTHORNE HILL STABLE. The stable at Hawthorne Hill was done in the Arts and Crafts style. This movement found its expression in the United States from around 1890 to 1920. The building was designed to fit into the natural environment as if it were meant to be there. The Thayers were widely known for their fine horses and carriages. (TML.)

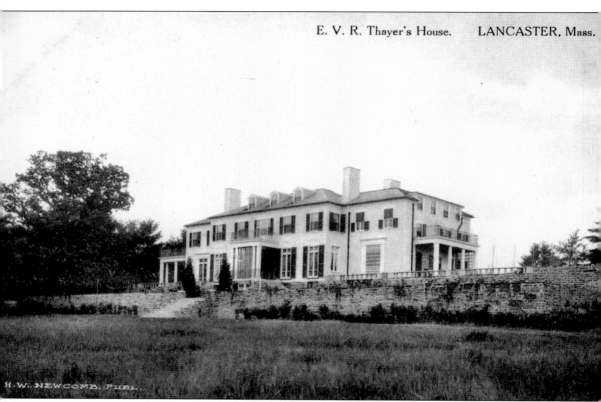

CROWNLEDGE. After Eugene V. R. Thayer II married Gladys Brooks in a lavish Newport wedding in 1903, the young couple decided to build a country home in Lancaster. Plans for the $200,000 estate were done by the Boston firm of Winslow and Bigelow. Henry Forbes Bigelow was well known to the family, as he had recently completed work on the Col. J. E. Thayer's Bird Museum and would soon marry Eugene V. R. Thayer II's sister Susan.

REAL LOVE STORY. Unfortunately, the "real love story" of Eugene V. R. Thayer II and Gladys Brooks came to an end, and the couple divorced a few years later. Eugene later married Elizabeth Harding Prince in 1923. He died in 1937. Gladys lived on to the age of 94, passing away in 1976. She was an avid collector of antique furniture, china glass, prints, and other artifacts. Over the years, she gave many of her collections to museums and other institutions. (TML.)

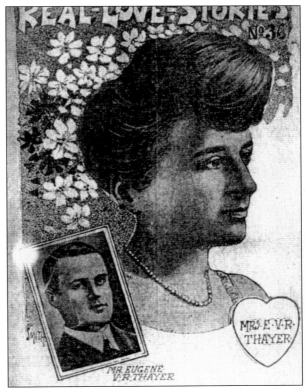

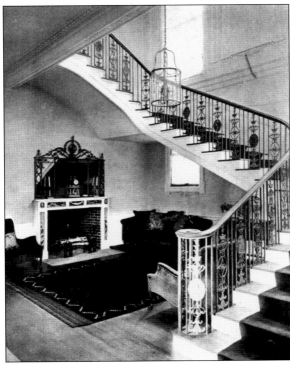

CROWNLEDGE STAIRCASE HALL. Pictured is the elegant, curving staircase in the entrance hall. (TML.)

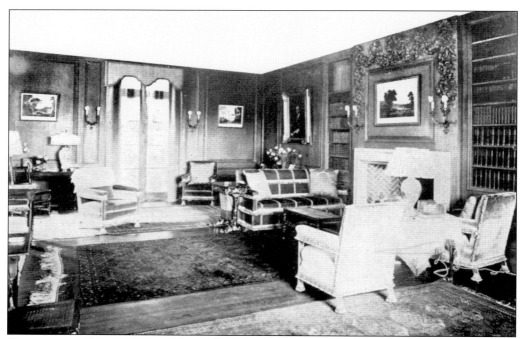

CROWNLEDGE LIVING ROOM. This well-furnished living room featured carving over the mantel that was similar to that in the children's room of the Thayer Memorial Library. It is thought to be the work of Dutch-born wood carver Grinling Gibbons. (TML.)

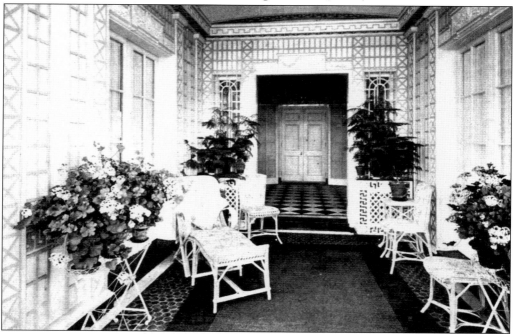

CROWNLEDGE LOGGIA. The open gallery, or loggia, beyond the entrance hall of the house featured intricate latticework similar to that found in the Homestead's sitting room by Ogden Codman. (TML.)

Seven

SCHOOL DAYS

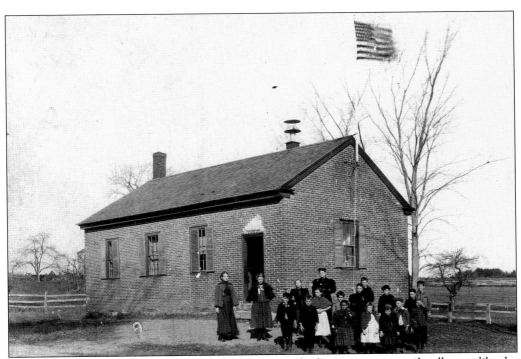

ONE-ROOM SCHOOLHOUSE. In the early days, Lancaster had many one-room schoolhouses like the one pictured here. The last one-room schoolhouse in Lancaster was used until the 1920s. (TML.)

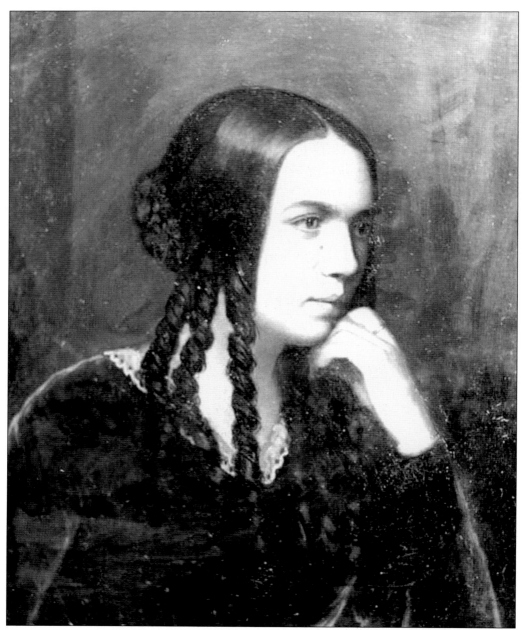

JULIA FLETCHER CARNEY. A Universalist, early feminist, teacher, and writer for children, Julia Fletcher Carney (1823–1908) composed a poem in 1845 entitled "Little Things," which was once well known and widely memorized by American schoolchildren. Young Julia also distinguished herself in Lancaster by keeping good order in her Ponakin district classroom during a 12-week term without the threat or use of corporal punishment. Previously, the male teacher had been turned out of doors by his unruly students. When she married, Julia moved west, settling in Galesburg, Illinois. In her later life, she occasionally made trips to visit family members in her native Lancaster. This painting of Julia was likely created by Samuel Osgood in Boston about 1845.

Little Things

Little drops of water,
　Little grains of sand,
Make the mighty ocean
　And the pleasant land.

So the little moments,
　Humble though they be,
Make the mighty ages
　Of eternity.

So the little errors
　Lead the soul away
From the paths of virtue,
　Far in sin to stray.

Little deeds of kindness,
　Little words of love,
Help to make earth happy,
　Like the heaven above.

1845　　　Julia A. Fletcher

"LITTLE THINGS." When Julia Fletcher composed her little poem, she did not realize how popular it would become. One evening, she wrote the first verse as part of "A Letter to Sabbath School Children" for her editor. Early the next day, she attended a teacher's morning class in Pitman's Phonography at the Tremont Temple in Boston. As part of a 10-minute writing exercise, she dashed off some more verses to add to the one from the previous night. Later, when her editor called for "scraps" to fill corners, she sent the poem to him. Unfortunately, she did not sign it. After years of being attributed to others or listed as "anonymous," the poem was finally credited to Julia.

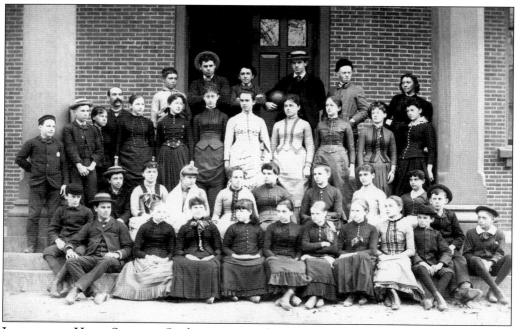

LANCASTER HIGH SCHOOL. Students in attendance during 1886 pose on the steps of the Lancaster Town House on the green.

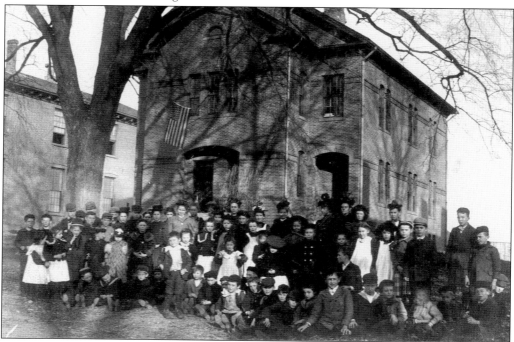

LANCASTER ACADEMY BUILDING. A large group of grammar school students poses in front of the Lancaster Academy Building around 1900. The building was located just south of the old Lancaster Town House on Main Street in Lancaster Center. It was replaced with the new Center School in 1903. (TML.)

MARY B. S. BAILEY. Mary Belle Sophronia Bailey (1871–1957), a native Lancastrian, was born in the Ponakin area of town. Before her 1938 retirement, she devoted 35 years of her life to the teaching profession, serving as a music teacher and supervisor in the Lancaster schools. She is fondly remembered by longtime residents as a kind but strict teacher who always wore long skirts down to her ankles and shirtwaist blouses with white collars and cuffs. Bailey, a member of the Evangelical Congregational Church, was choir director and organist for 36 years and was always active in the charitable works of her church, town, and community.

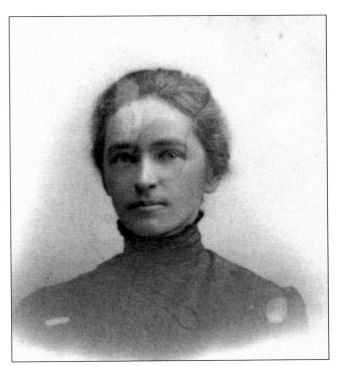

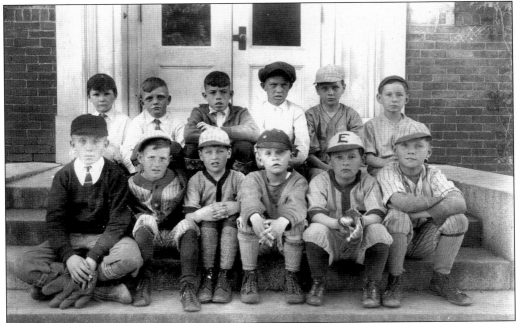

BOYS' BASEBALL. These boys' baseball team members sit on the south steps of the Center School in Lancaster in the early 20th century. From left to right are the following: (first row) Tom Reiner, Francis Threadgold, unidentified, Tim Reiner, Duncan MacDonald, and Ned Reiner; (second row) Roland Petrie, Alfred Tracy, George Threadgold, Fred "Cy" Jarvis, Doug Anderson, and George "Gidi" Osborne.

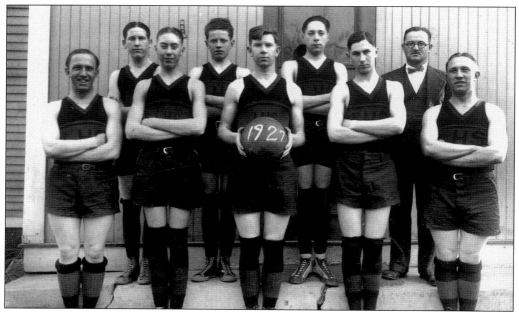

BASKETBALL TEAM. The 1927 Lancaster High School basketball team poses for a photograph. From left to right are one of the Laffin twins, Coleman Wilson, Herb Cutler, Craig Wilson, Charlie Green, George Gleezen, John Gilmore, coach Maurice Gregory, and the other Laffin twin.

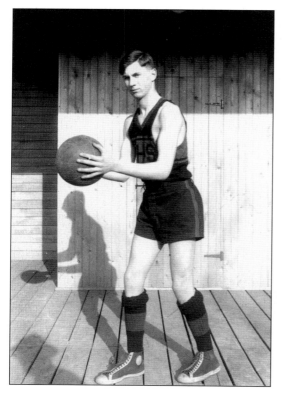

JOHN GILMORE. Gilmore is seen here in 1927, when he played basketball for the Lancaster High School team. He was the only graduate of Lancaster High the year he graduated. Interestingly, this image shows not only his shadow but also that of the photographer.

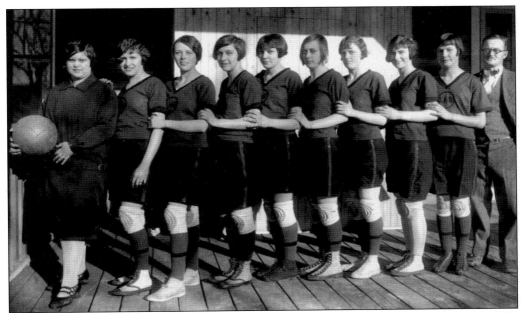

LADY HOOPSTERS. These young ladies pose for James MacDonald sometime around 1927. Three of the girls are identified: Viola Thomas Hastings (third from left), Beth MacMackin Green (seventh from left), and Grace Kanis Sachse (ninth from left). Coach Maurice Gregory is on the far right.

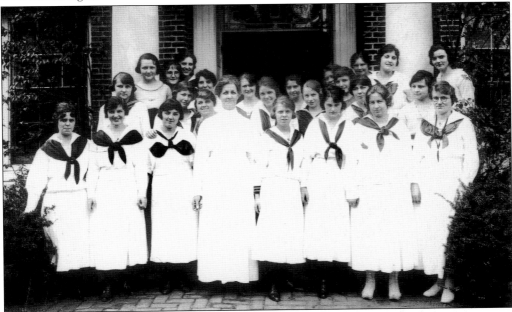

LADIES OF LANCASTER JUNIOR COLLEGE. A group of young women from Lancaster Junior College poses with Mrs. Stevens, their preceptress, in front of the Thayer Ornithological Museum. The middy suits they are wearing, recommended as suitable school attire, were very popular during this time. The school was known as Lancaster Junior College from 1918 to 1922. In 1922, the school became Atlantic Union College. (AUC.)

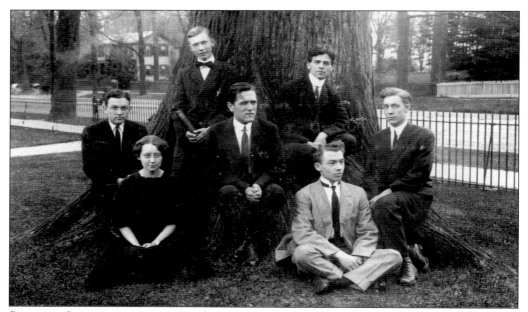

SERIOUS STUDENTS. A group of serious students poses on the lawn of the Thayer Ornithological Museum in the early 20th century. (AUC.)

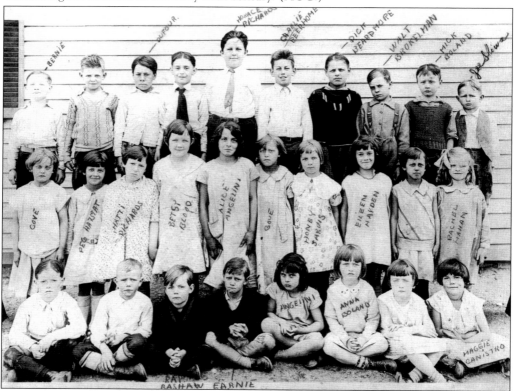

BALLARD HILL CLASS. Students from the Ballard Hill School are shown in this class photograph, taken in the early 1930s. (Watson.)

BALLARD HILL CLASS. Another group of students from the Ballard Hill School poses with their teacher in the early 1930s. (Watson.)

CENTER SCHOOL CLASS. This image of a class from the Center School was taken in the early 1930s. (Watson.)

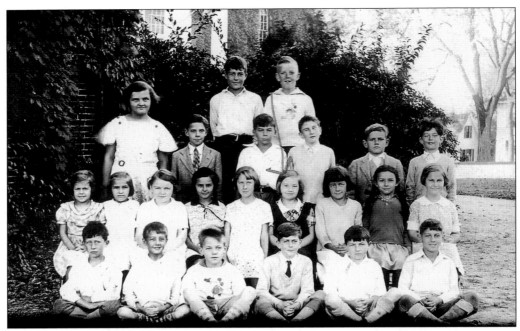

CENTER SCHOOL CLASS. This class was photographed around 1935. (Maurer.)

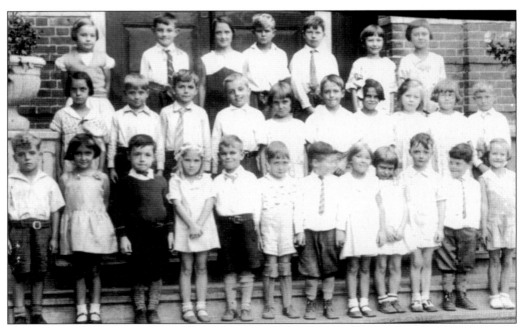

NARROW LANE CLASS. Shown here in 1931 is the first- and second-grade class from the Narrow Lane School in South Lancaster. Buddy Connor, who was later killed in World War II, is the first student on the left in the first row. (Maurer.)

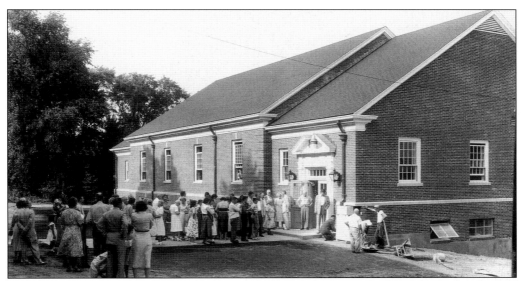

TERCENTENARY BUILDING. Completed in 1953, this multipurpose building, located in back of the Center School on the town green, was designed to fill many needs. There would be classroom space for grades one through three, a new kitchen and lunchroom, and a combination gymnasium and auditorium for student and community use. Here, the cornerstone is laid during the Tercentenary Week celebration. Today, the building is no longer in use. (TML; photograph by Walter's Photo Lab.)

MEMORIAL SCHOOL. Forecasts in 1954 indicated that more classroom space would be needed. By 1955, plans had begun to build and equip a 12-room elementary school addition to the Tercentenary Building. It was to be an economical, substantial building of brick-faced cinder block without any extravagant features. It was completed in September 1956. Today, the building is no longer in use.

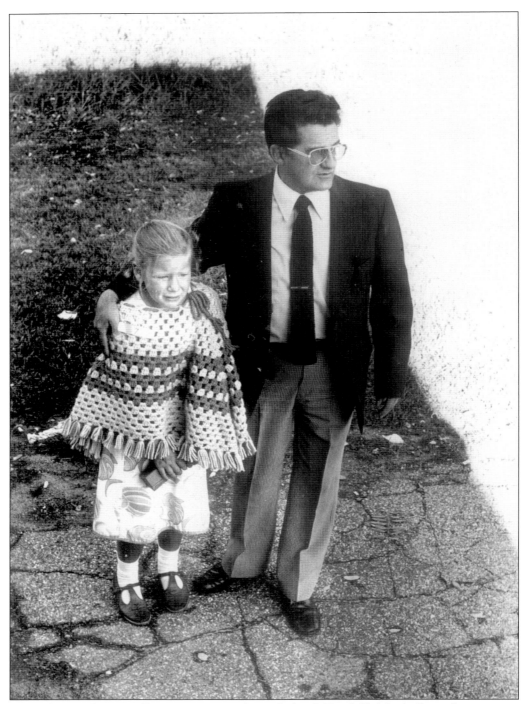

FIRST DAY OF SCHOOL. Former superintendent of schools Frank H. Mitchell comforts a young first grader as she awaits her bus on the first day of school in September 1981. Mitchell served as Lancaster's superintendent of schools for kindergarten through eighth grades for 26 years, from 1964 to 1990. (Mitchell, Item.)

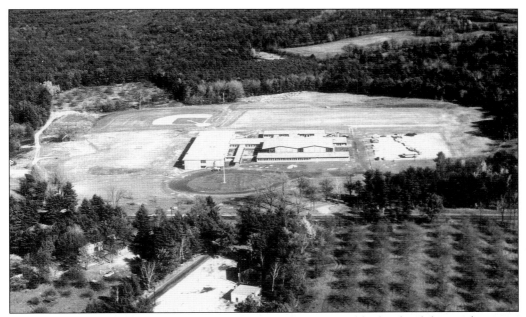

NASHOBA REGIONAL HIGH SCHOOL. The new, modern regional high school designed to serve the youth of Bolton, Lancaster, and Stow opened on September 6, 1961. Student capacity for the new school was 600, with enrollment the first year at 389. Almost half the students that year were from Lancaster. (NRHS.)

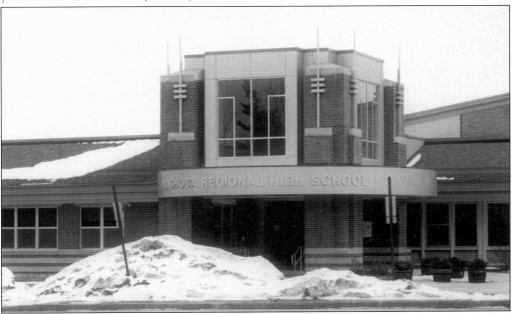

NASHOBA ADDITIONS. By the end of the 1960s, the facility had proved inadequate to handle the school's baby boomer enrollment. In 1969, the citizens of Bolton, Lancaster, and Stow voted to expand and create an educational program suitable for 1,200 students. After 2000, another addition included a new auditorium and better handicapped accessibility. This 2005 photograph shows the new entrance to the school.

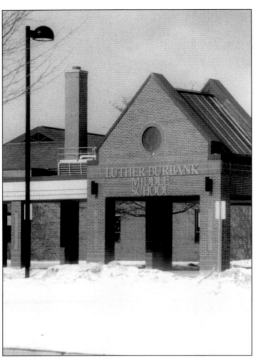

LUTHER BURBANK MIDDLE SCHOOL. Originally built in 1974 and known as the Lancaster Middle School, this facility was renovated in 2002 and currently serves sixth- through eighth-grade students. It has 16 classrooms and an enrollment of 240. The school is now named for plant wizard Luther Burbank, who was born in Lancaster in 1849.

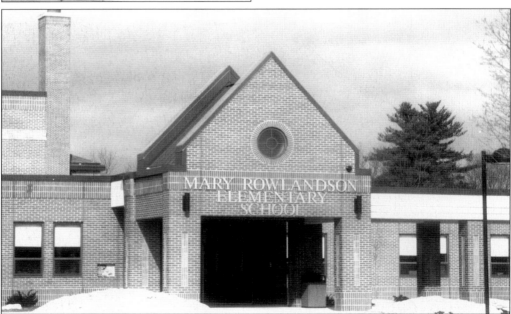

MARY ROWLANDSON ELEMENTARY SCHOOL. Constructed in 2002, the school currently serves pre-kindergarten through fifth-grade students. It has 22 classrooms and a current enrollment of 470. Adjacent to the Luther Burbank Middle School, it is named for the early Lancaster minister's wife, who was captured and later ransomed after American Indians attacked the town in the winter of 1675–1676. Mary later wrote a well-known account of her ordeal, entitled *A True History of the Captivity and Restoration of Mrs. Mary Rowlandson.*

Eight

EARTH, WIND, AND WATER

NASHUA RIVER. The beautiful Nashua River takes its name from the Native American word *Nash-a-way*, meaning "River with the Pebbled Bottom." From the Meeting of the Waters in Lancaster, the river flows in a northeasterly direction for 56 miles toward New Hampshire and the Merrimack River. This view shows an annual clean-up day in 1999. (Balco.)

GLIMPSE OF THE NASHUA. This tranquil image of the Nashua River was done by local artist Harry B. Chatterton. Though born in Milwaukee, Wisconsin, in 1868, he moved to Lancaster and lived on Mill Street for 37 years until his death in 1951. He had a studio in his Mill Street home and was known primarily for portraiture. (Christoph.)

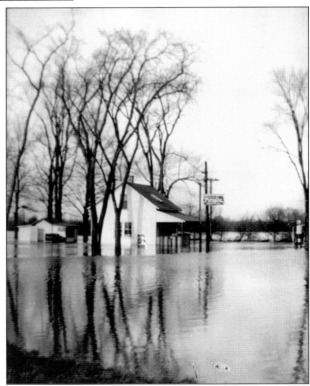

RISING WATERS. The flood of 1936 causes water to rise high around a small filling station at Five Corners.

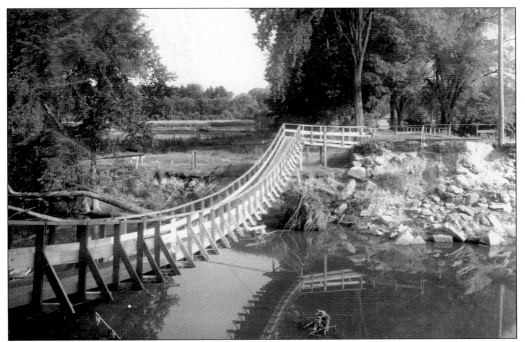

FOOTBRIDGE. This temporary footbridge was constructed at the Center Bridge after the flood of 1936 had washed out the main span.

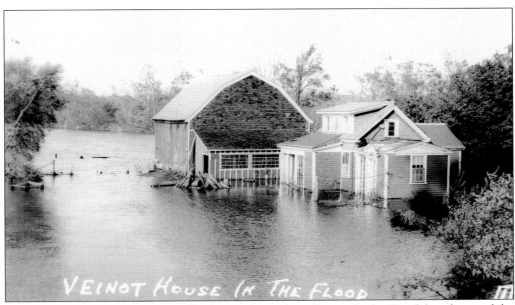

VEINOT HOUSE IN THE FLOOD. This house, located on Center Bridge Road (southeast of the bridge), appears to be in the middle of a lake during the flood of 1936.

DAMAGE NEAR EASTWOOD CEMETERY. During the Hurricane of 1938, signs and trees were blown down all over the town, as shown in this view near Eastwood Cemetery.

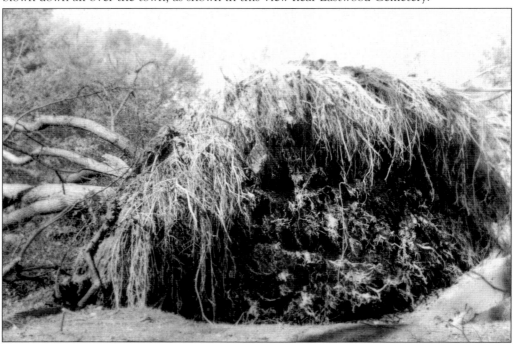

MASSIVE BALL OF ROOTS. As the powerful Hurricane of 1938 descended upon Lancaster, countless trees were felled. James MacDonald photographed some of the massive root balls unearthed, as seen here.

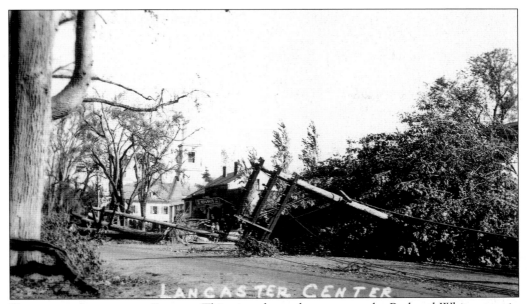

DAMAGE IN LANCASTER CENTER. This view shows damage near the Red and White store in the center of town after the Hurricane of 1938.

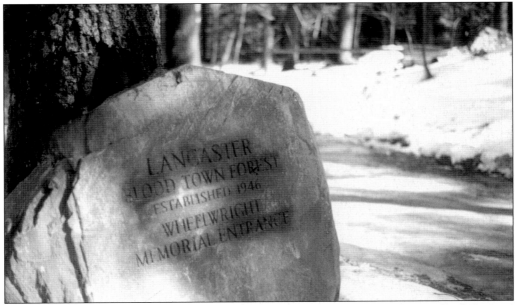

ARTHUR W. BLOOD TOWN FOREST. In 1946, Lancaster resident Arthur W. Blood donated approximately 125 acres of forestland to the town. This, added to some town land, brought the amount to the 150 acres making up the original Blood Town Forest. It has approximately 600 acres today. This photograph shows the stone erected in 1956 to mark the Wheelwright Memorial Entrance on Brockelman Road. George W. Wheelwright was the original chairman of the town forest committee.

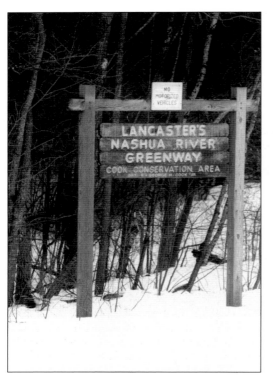

COOK CONSERVATION AREA. In 1977, the Lancaster Conservation Commission installed a sign for the North Greenway area on Lunenburg Road. It was named for George Cook Jr. of Leominster, who had donated 104 acres of land on both sides of the river and extending about one mile along the banks. The Cook Conservation Area and Lancaster State Forest now consist of about 800 acres, with six miles of trails along the North Branch of the Nashua River.

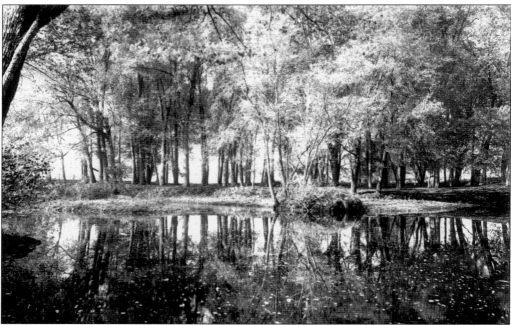

PARKER FAMILY WOODS AND POND. In 1986, Cornelia C. Parker donated a 60-acre parcel of land and a pond that had been in her family for years to the New England Forestry Foundation to protect it from future development. The small, brook-fed Parker's Pond (shown here) is located in the woods near the south end of Goss Lane in South Lancaster.

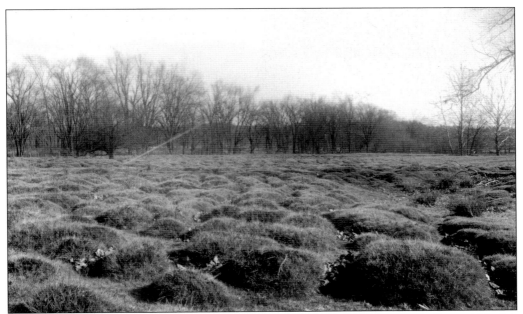

OLD SWAN SWAMP. Located on the south side of the old toll road that is now Route 117, this swamp was often referred to in old deeds. The unusual hummocks shown here were caused by the action of spring freshets and winter frosts over long periods of time. The formations have long since been plowed under.

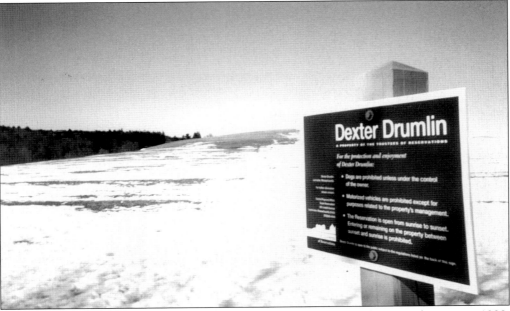

KILBOURN HILL/DEXTER DRUMLIN. Town father Nat Dexter, who passed away in 1999, donated this 35-acre parcel of land on the north side of George Hill Road to the Trustees of Reservations. Shaped like an inverted teaspoon, the hill provides wonderful winter opportunities for sledding and tobogganing. At one time, the Kilbourn family had a large farmhouse and land nearby—hence the earlier name of Kilbourn Hill.

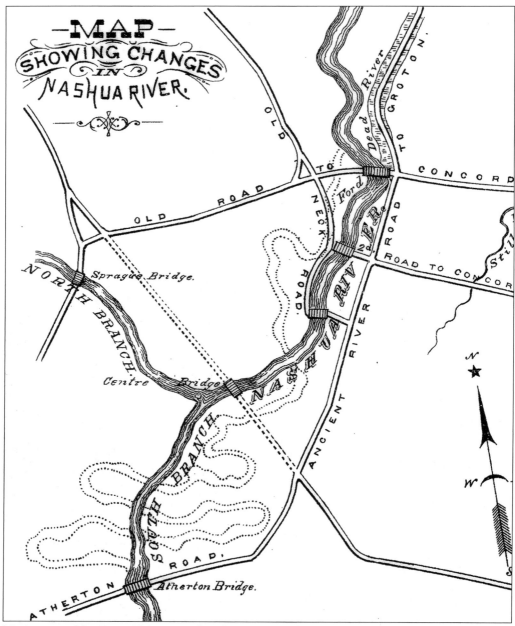

MAP OF THE NASHUA. This map, taken from Abijah Marvin's *History of Lancaster*, shows some of the early roads and bridges on the Nashua. Long ago, when the town's center was on the Old Common, to head north, travelers took a long bridge across the floodplain from Five Corners to the large curve in Neck Road. Farther north, at Lane's Crossing (where Harvard and Seven Bridge Roads cross), the traveler could take the Post Road west toward Brattleborough, Vermont, or continue north up Harvard Road. This map also shows the Neck area (across the upper part of the Y made by the river lines above). This long plateau of land sloping gently down to the river on both sides extends northward from the Meeting of the Waters to the southern base of Ponakin Hill (not shown on this map). All of Lancaster Center is on the Neck. (Grout.)

LEE PIERCE "BILL" FARNSWORTH
(1921–1995). Born in Lancaster, longtime
resident Bill Farnsworth initiated the
Nashua River Study Committee in 1962
and, in 1963, recommended a Nashua River
greenway in the 1963 selectman's annual
town report. Regionally, he is credited with
cofounding the Nashua River Watershed
Association with Marion Stoddart of
Groton and several area people in 1969.
In later years, he continued as a member
and board director. (Farnsworth.)

IN MEMORY OF
BILL FARNSWORTH
1921 · 1995
FATHER OF THE
NASHUA RIVER

FARNSWORTH MEMORIAL BRIDGE AND PLAQUE. In 1995, the bridge spanning the Nashua on
Bolton Road in Lancaster was named for Bill Farnsworth, who had spent more than 25 years
working to make the Nashua River healthy again and to ensure that with a "ribbon of green"
along much of it, it would remain so. This plaque marks the memorial bridge. (Farnsworth.)

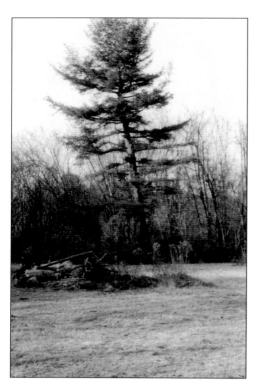

ROWLANDSON PINE. Planted in 1853 (the year of the town's 200th anniversary), this commemorative tree withstood many storms, including the Hurricane of 1938. However, the tree had been deteriorating for a long time, and the trunk was nearly hollow. (Jacobs.)

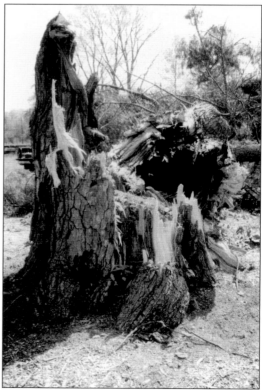

FALLEN TREE. Sadly, the tree fell victim to powerful storm winds on May 3, 2002. This view shows the snapped trunk of the Rowlandson Pine right after the storm. Losing the tree was a sad event for the town of Lancaster. (Jacobs.)

Nine
SMALL-TOWN LIFE

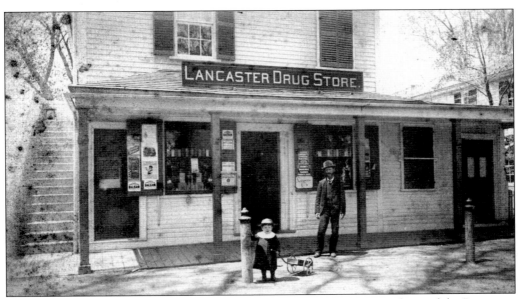

OUT WITH DADDY. A. E. Harriman and his young son C. H. appear in front of the Lancaster Drug Store around 1884. The building was located on the west side of Main Street in Lancaster Center. It is no longer standing.

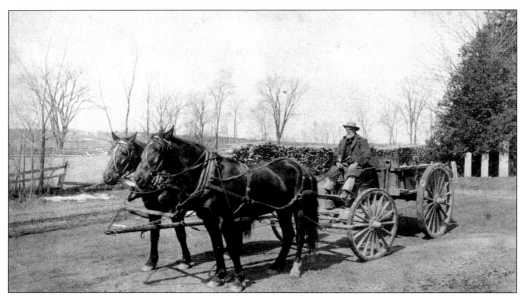

EARLY DEPARTMENT OF PUBLIC WORKS. Sanford B. Wilder is pictured here with the "Town Team," which was used jointly by the road and fire departments. This photograph was taken near the entrance of the North Village Cemetery about 1890.

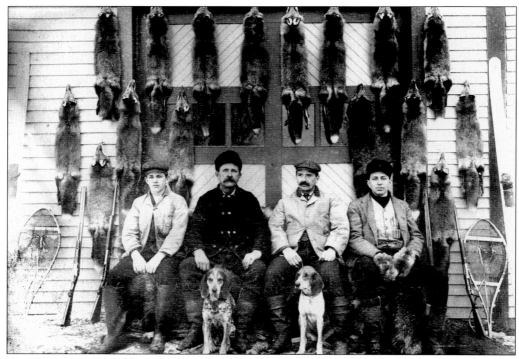

FOX HUNTERS. Proud hunters stand with their hounds and display the foxes retrieved. Likely posing in back of Lancaster Center's general store, they are, from left to right, Guy C. Hawkins, Lyman Sanborn Sr., Everett M. Hawkins, and Arthur G. Chickering.

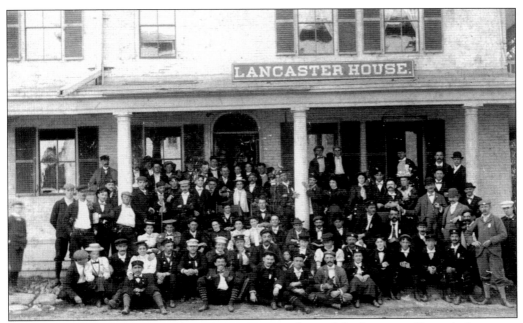

MEETING IN LANCASTER. Bicycle enthusiasts pose in front of the Lancaster House in Lancaster Center on September 19, 1897. There, the Rollstone Cycle Club of Fitchburg hosted a complimentary dinner for 20 members of Boston's Commonwealth Cycle Club.

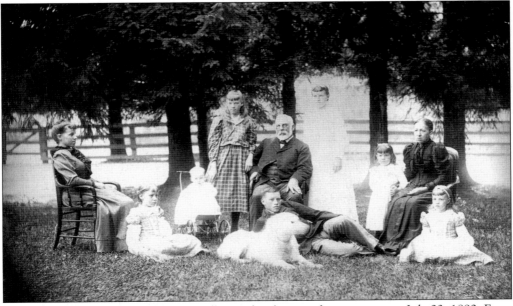

KILBOURN FAMILY PORTRAIT. The Kilbourn family poses for a portrait on July 23, 1892. From left to right are the following: (first row) Arthur (16 years) and dog Oscar Wilde (11 years); (second row) Martha (20 years), Alice (10 years), Walton (1 year), Mary (12 years), William A. Kilbourn Sr. (54 years), Elizabeth (17 years), Ruth (4 years), Abbie (45 years), and Annie (8 years). William A. Kilbourn Sr. (1838–1912) was an educator and later the general manager for the Thayer properties in Lancaster. (Kilbourn.)

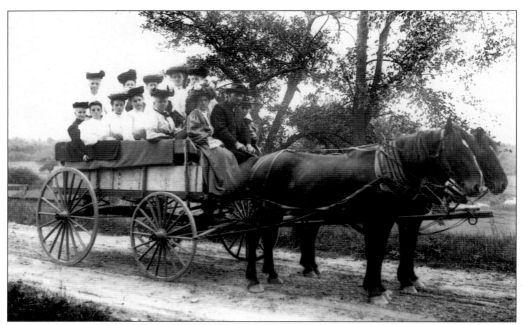

WAGONLOAD OF LADIES. Photographed by James MacDonald, these unidentified women are dressed up in their Sunday best and are ready to enjoy some good times.

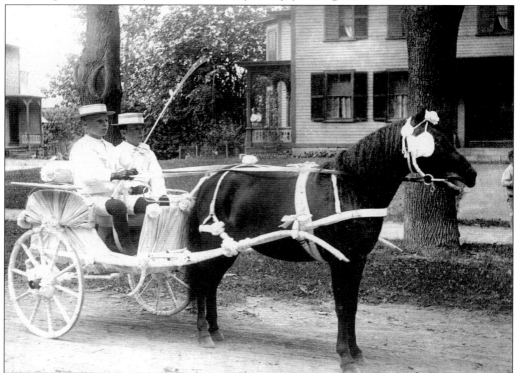

OUT AND ABOUT. A young John E. Thayer III (left) and Harold Parker pose in a pony cart decorated for a special occasion.

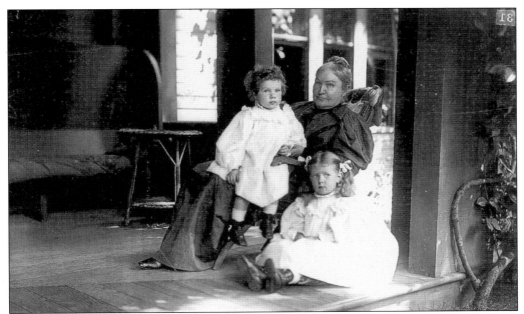

AFTERNOON WITH GRANDMA. In this *c.* 1900 photograph, Cornelia "Connie" (left) and Elizabeth Parker (right) sit with their grandmother Harriet Felton Parker on the porch of their estate in South Lancaster.

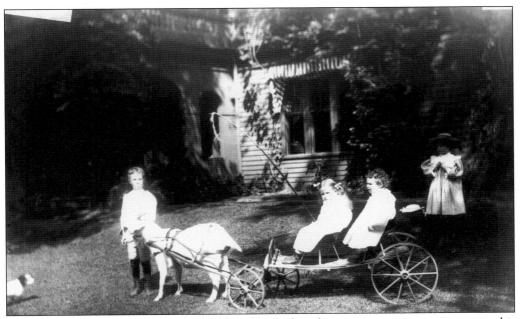

GOAT POWER. The children of Harold Parker had at least one very interesting toy—this miniature, billy-goat-powered buggy. From left to right are George, Edith, Cornelia, and Catherine. This scene takes place in front of a former Parker mansion in South Lancaster.

LANCASTRIANA CLUB. Composed mainly of members from the First Church, this gentlemen's social club met monthly for dinner beginning in 1910. From left to right are the following: (top row) Henry H. Fuller, Arthur T. Harris, John E. Thayer II, George Morse, and Harold Parker; (bottom row) Herbert Parker, Rev. Abbot Peterson, Thomas Temple, Bayard Thayer, and Eugene V. R. Thayer II.

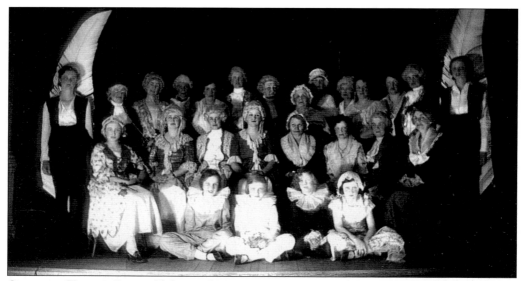

CURRENT TOPICS CLUB. Club members pose at a New Year's Eve event around 1929. The women are, from left to right, as follows: (first row) Patty Chickering, Sally Chickering, Ruth Morse, two unidentified members, Ruth Hardy, unidentified, and Frances Glover; (second row) Mildred Treadwell, Esther MacDonald, Rochelle Kilgore, Connie Parker, Gladys Kilbourn, ? Martin, May Worcester, Emily Wheelwright, Louise Chickering, Grace Spaulding, Agnes Richter, and Mabel Safford. The children seated in front are, from left to right, ? McCarty, unidentified, ? McCarty, and Virginia Spaulding.

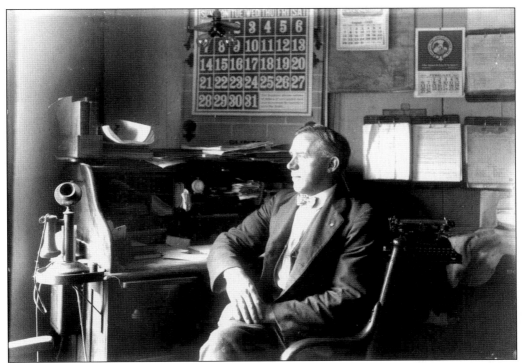

STATION MASTER. For longtime area residents, this photograph conjures nostalgic feelings of way back when. Railroad station master Elmer Cheney sits at his rolltop desk in the Lancaster train station. Note the old telephone at the left. The calendar on the wall is for 1927.

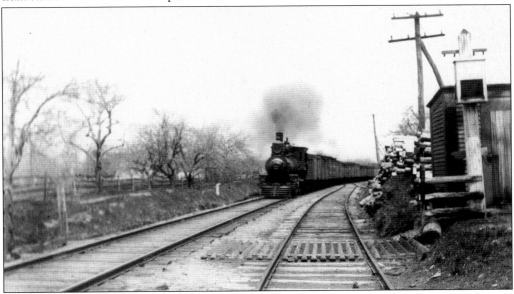

STEAMING TO LANCASTER. Here, an old steam-powered locomotive heads to an unknown destination somewhere in the Lancaster area around 1900. The Worcester and Nashua Railroad, which came to Lancaster in 1849, made the town more accessible and open to new influences and opportunities.

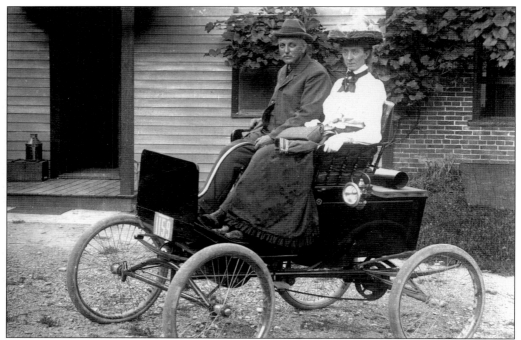

ELECTRIC CAR. An unidentified man and woman are all ready for a leisurely afternoon's drive through the country in their new horseless carriage.

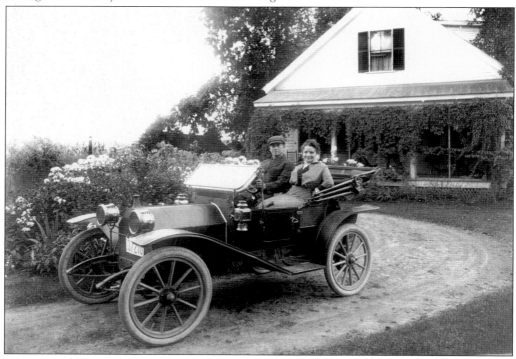

AFTERNOON RIDE. The happy couple, posing in front of a house on the corner of Old Common and Bolton Station Road, prepares to take their new Hupmobile for a spin.

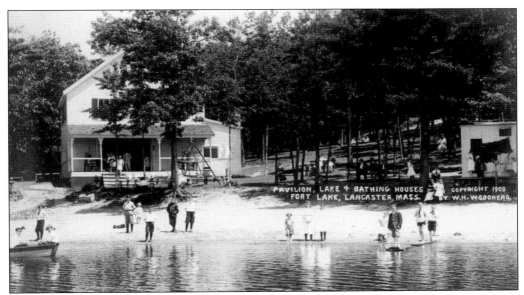

FORT LAKE. This postcard view shows some fun at Fort Pond around 1900. (Hart.)

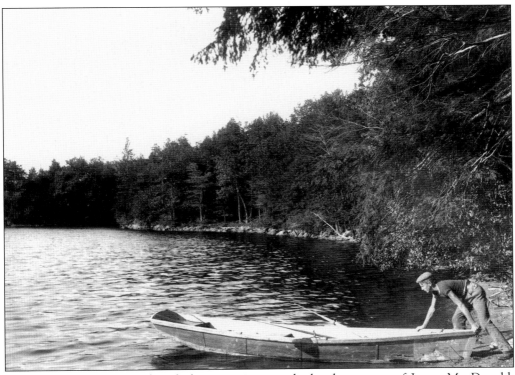

ON THE POND. This unidentified young man, caught by the camera of James MacDonald, prepares to take advantage of a warm summer afternoon in the early 1900s.

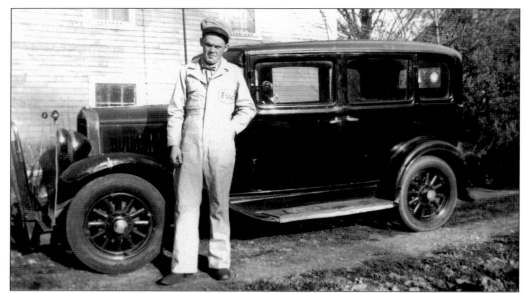

ESSO MAN. Lancaster resident Frank Ponte, with his 1931 Dodge, is all ready for work. This photograph was taken in front of the Lancaster Hotel Annex, Ponte's residence at the time. Note the old wooden spokes on the wheels of the vehicle. (Ponte.)

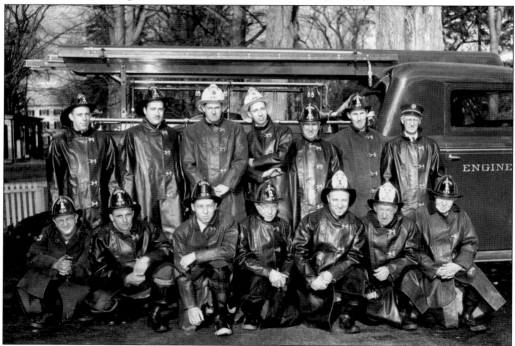

LANCASTER FIREFIGHTERS GROUP. This *c.* 1942 group of firefighters includes, from left to right, the following: (first row) Vinny Dyment, Nat Hawkins, Jack McLaughlin, Freeman Dyment, George Neault, Dewey McGee, and William Dyment; (second row) Elwin Locke, Frank Collins, John Malone, Wilbur Locke, George Mosher, John Gilmore, and Capt. Herbert Fentimen. (Paquette.)

POLICE CHIEF RYDER. Looking very official in his uniform is Lancaster police chief Patrick H. Ryder (1918–1987). When he retired in 1982, Lancaster selectmen proclaimed Thursday, December 2, Patrick H. Ryder Day in recognition of his 34 years of faithful service to the town. (Item.)

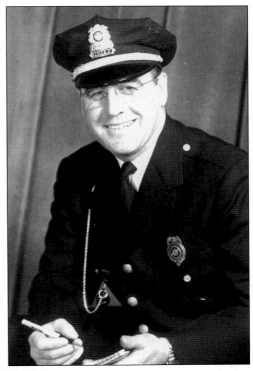

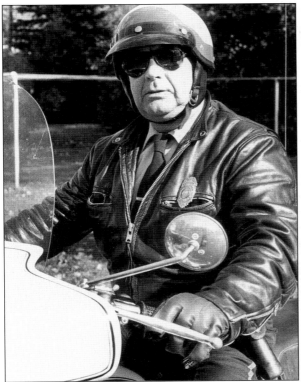

POLICE SERGEANT PELLETIER. Keeping Lancaster roads safe was always a concern for Sgt. Walter E. Pelletier (1918–1990), shown here. From 1953 through 1983, he served the town of Lancaster in several capacities, including a full-time police officer, police sergeant, constable, and a member of the highway safety committee and board of road commissioners. (Item.)

115

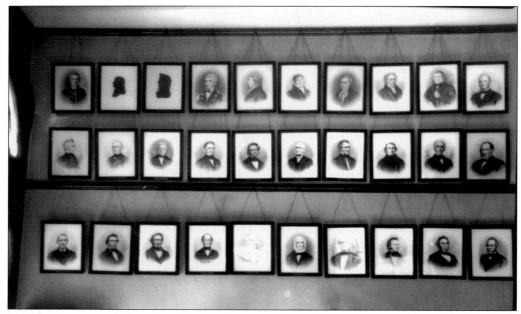

TOWN FATHERS. All the official portraits of Lancaster's selectmen hang in the town hall. There are likenesses of each, from the earliest times to the present day.

LANCASTER'S FIRST TOWN MOTHER. Shown here is Lancaster's very first selectwoman. Virginia Collins began her service to the town in 1950, working in various capacities and on several committees through the years. Her term as the town's first selectwoman ran from 1973 to 1976. (Item.)

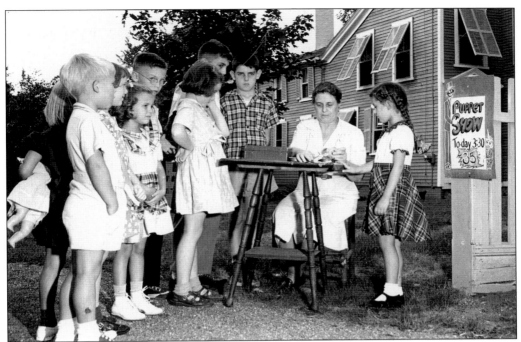

PUPPET SHOW. Area children line up as Helen Grout issues tickets for a puppet show at the Toy Cupboard Theatre around 1949. This photograph was taken when the theater was still located on the corner of Main Street and George Hill Road in South Lancaster. Puppeteer Herbert Hosmer, who had started the theater in 1941, later operated it from a George Hill site adjacent to his new home. (Schumacher-Hardy.)

PUPPET THEATER. In this view, Herbert Hosmer's Puppet Theater stands adjacent to his new residence on East George Hill Road. The building was designed from a 250-year-old carriage house and made a charming setting for a children's theater, with its pine-sheathed walls, pegged beams, and slatted outside archways.

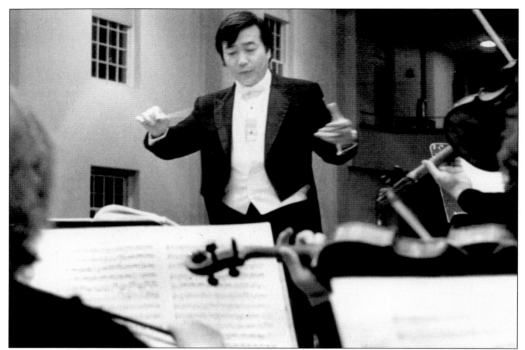

MAESTRO IN ACTION. An energetic maestro Toshimasa Wada, director of the Thayer Symphony Orchestra, takes charge at a performance in Machlan Auditorium on the campus of Atlantic Union College. (Item.)

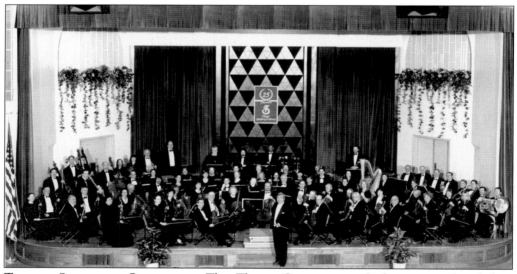

THAYER SYMPHONY ORCHESTRA. The Thayer Conservatory Orchestra was founded at Atlantic Union College by Dr. Jon Robertson in 1974. In 1983, maestro Toshimasa Francis Wada became the third director. The Thayer Symphony Orchestra, as it is now known, moved to Fitchburg at the end of the 2000 season. Here, the orchestra readies for a concert in Machlan Auditorium celebrating its 25th year. (TSO.)

118

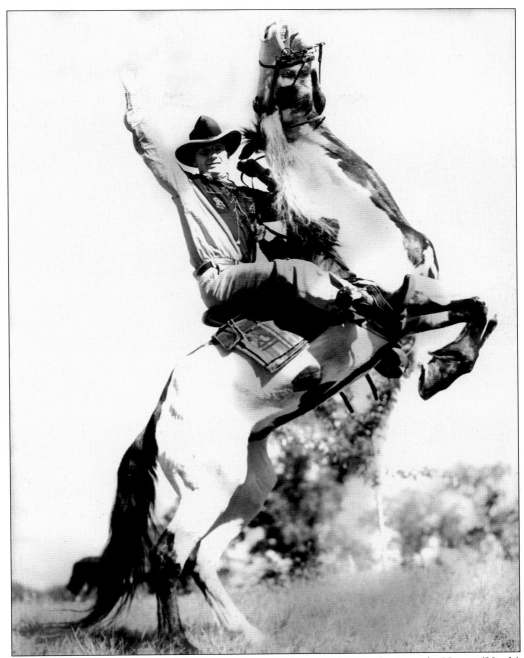

THE MAN WHO LOVED HORSES. As one can tell from this 1937 photograph, Henry (Hank) St. Jacques (1901–1963) loved horses. He lived in the Lancaster-Clinton area for more than 50 years and operated a riding school. Before World War II, it was located near Sterling Road and Sawyer Street. After World War II, it was moved to a location off Old Common Road near Bolton Station Road. Lessons in the ring and trail rides with Hank created many fond memories for more than one generation of kids who grew up in Lancaster. This horse was named Tex. (Laurence.)

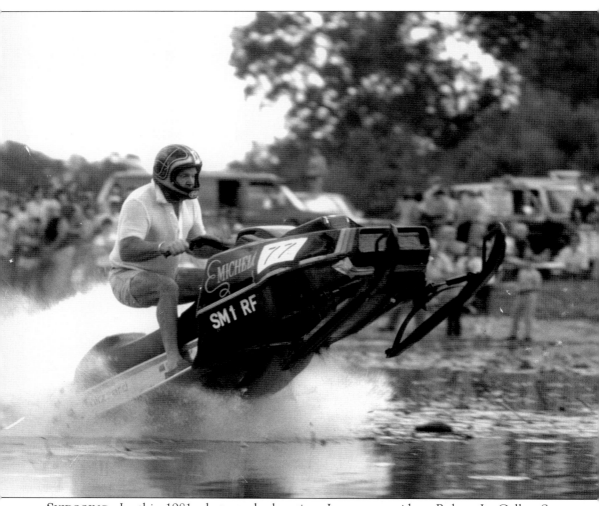

SKIDOOING. In this 1981 photograph, longtime Lancaster resident Robert L. Culley Sr. (1924–2005) actively participates in a "water cross" competition at his snowmobile ranch along Route 117. The snowmobile ranch was founded in 1963. (Culley.)

Ten

MEMORIALS AND
ANNIVERSARIES

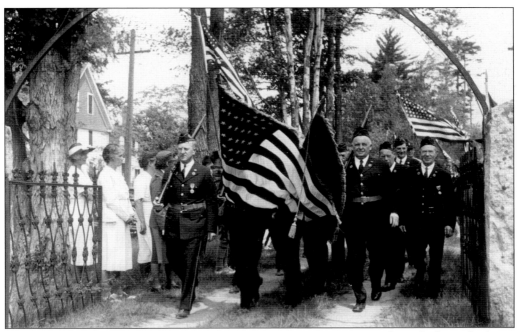

NORTH VILLAGE MEMORIAL DAY. An American Legion group passes through the arched gate at the North Village Cemetery around 1935. Standing near the gate on the left is Evelyn Fentiman. Marching are, from left to right, Howard Bryant, Jack Lynch, Dr. Edward Bartol, Rev. Frederick Weis, and William Dyment. (Paquette.)

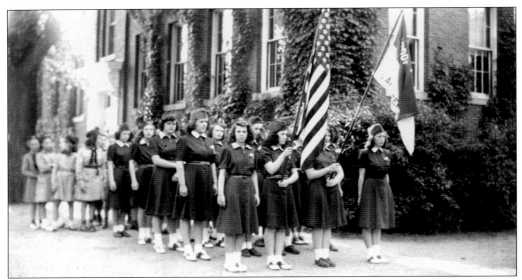

MEMORIAL DAY IN 1941. Girl Scouts assemble for a wartime Memorial Day parade. Marching in annual Memorial Day parades is a time-honored tradition with the group.

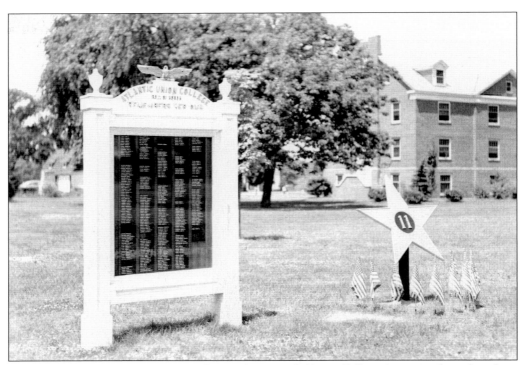

ROLL OF HONOR AND MEMORIAL STAR. A star and 11 small flags denoting those lost from Atlantic Union College during World War II are displayed near Rachel Preston Hall on the college campus. No fewer than 240 people connected with the college served their country during the war and were recognized on the college's roll of honor. (Hart.)

Hugh "Buddy" Connor (1925–1944). Lancaster's young Buddy Connor fell to sniper fire during World War II on the Isle of Saipan in the Pacific theater on July 26, 1944. In 1948, his body was among the 3,200 war dead brought home on the U.S. Army transport *Walter H. Schwenk*. Before final burial in Eastwood Cemetery, his body was put in the town hall to lie in state, the only Lancaster citizen to have been so honored.

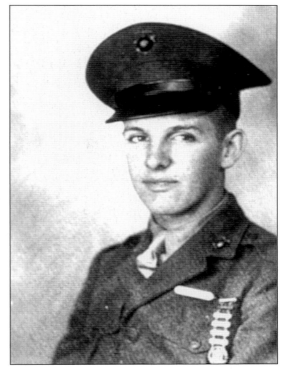

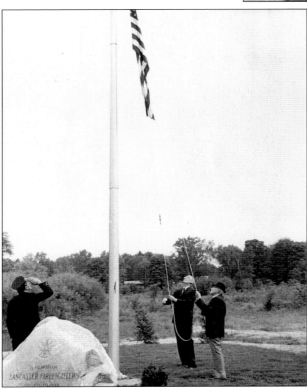

Firefighters' Memorial. In May 1976, a service was held honoring deceased members of the Lancaster Fire Department, organized in 1848. The monument was erected near the public safety building on Main Street. Seen here are David Silveira (left), James E. Bond (center), and William Dyment, who at 85 was then Lancaster's oldest living fireman. At that time, two Lancaster firefighters had been killed in the line of duty. (Paquette.)

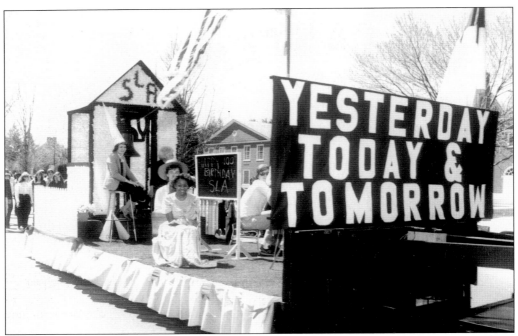

PARADE FLOAT. Shown here is a float in the Centennial Parade for South Lancaster Academy and Atlantic Union College. The two schools celebrated their 100th anniversaries in 1982.

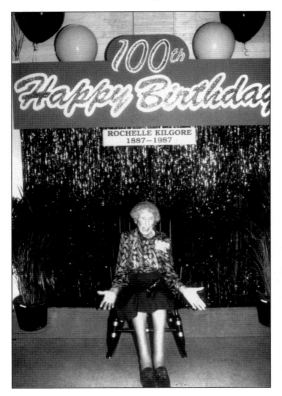

HAPPY 100TH, MRS. KILGORE.
A Lancaster resident from 1929 until her death, Rochelle Philemon Kilgore (1887–1993) lived to be almost 106 years of age. This English professor joined the staff at Atlantic Union College in 1936. After retiring in 1960, she stayed on campus, mentoring students and actively participating in alumni affairs. She was also a member of the Lancaster Historical Commission for many years. (AUC.)

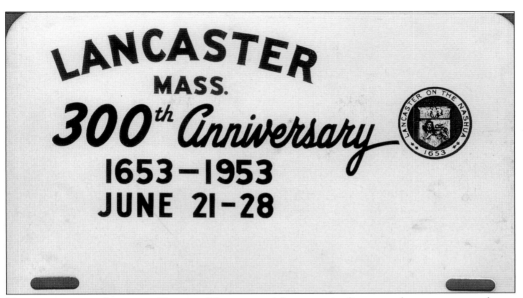

TERCENTENARY LICENSE PLATE. These special souvenir license plates were made to commemorate Lancaster's 300th anniversary in 1953. Tercentenary Week took place from June 21 to 28. (Sczerzen.)

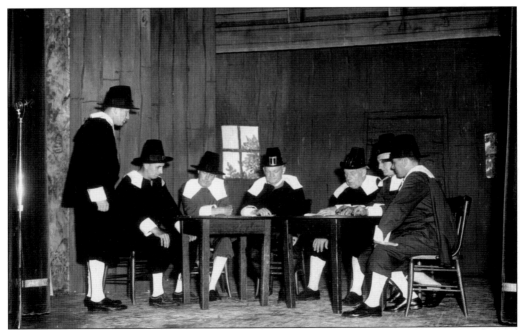

SIGNING THE COVENANT. As part of the 300th anniversary celebration, several townsmen enacted the signing of the 1653 town covenant. This photograph shows, from left to right, Frances Burgoyne, John Gilmore, John Freeman, Walton Kilbourn, William Sonia, Fred Willruth, and John P. Lynch. (TML; photograph by Walter's Photo Lab.)

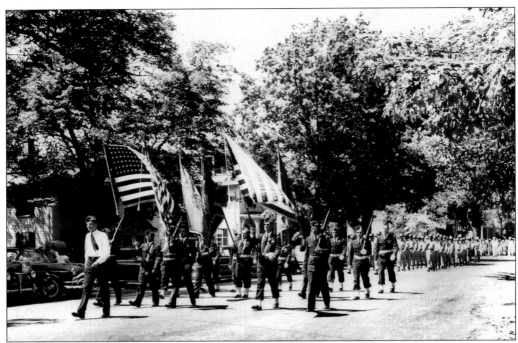

VETERANS IN PARADE. Area veterans march proudly down Main Street in the parade that was held on Saturday, June 27, 1953, during Tercentenary Week.

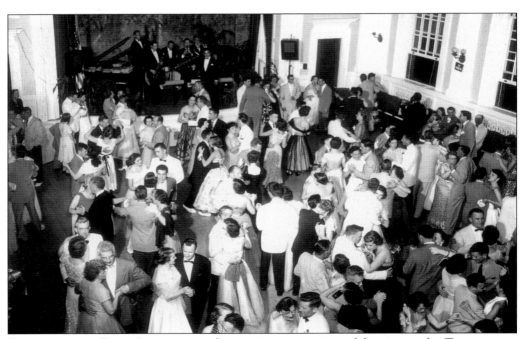

TERCENTENARY BALL. Lancaster residents enjoy an evening of dancing at the Tercentenary Ball, a highlight of the weeklong festivities. Music for the evening was provided by Ruby Newman's Orchestra. (TML; photograph by Walter's Photo Lab.)

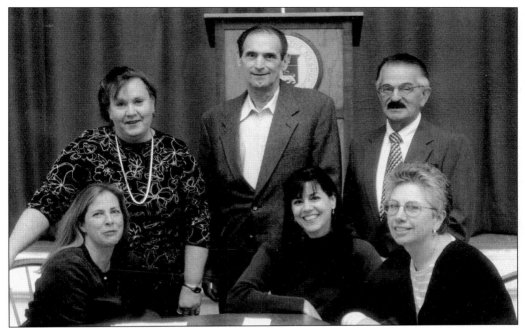

EXECUTIVE COMMITTEE. Members of the executive committee worked on planning for the town's big 350th birthday party from kickoff day on May 19, 2002, to the final parade on June 8, 2003. Shown, from left to right, are the following: (first row) Kate Hannigan, Christine Hvoslef, and Leslie Wilson; (second row) Marcia Jakubowicz, Robert Frommer, and chairman Frank T. MacGrory. Kevin Kerrigan is missing from the photograph. (MacGrory.)

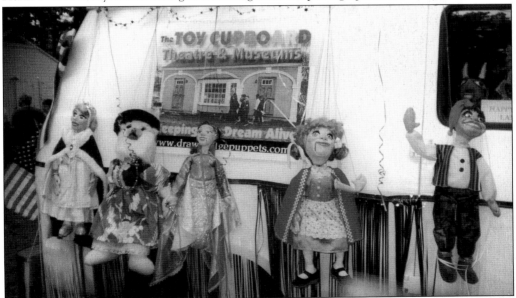

TOY CUPBOARD. This 350th anniversary parade entry brings to mind the puppet theater of the late Herbert Hosmer. Paul L'Ecuyer of Drawbridge Productions has carried on Hosmer's work, and John Schumacher-Hardy hopes to hold puppet shows in Hosmer's old theater building again one day. (TML.)

DAVIS FARM FLOAT. One of the area's remaining working farms wishes the town a happy 350th birthday. (TML.)

LANCASTER LAND TRUST FLOAT. This float represents Lancaster's "tree huggers." Members of the Land Trust, which began in 1996, are united by a desire to preserve and protect beautiful Lancaster on the Nashua for future generations. (TML.)